PIERRE BONNARD
Photographs and Paintings

PIERRE BONNARD
Photographs and Paintings

by Françoise Heilbrun and Philippe Néagu

An Aperture Book

This book was originally published in France in conjunction with the exhibition Bonnard photographe *at the Musée d'Orsay. Neither the exhibition nor this volume would have been possible without the generous contribution of the children of Charles Terrasse – Antoine, Jean-Jacques, and Michel Terrasse, and Françoise Vasiljevic – who kindly made available to us the photographs by Bonnard. We are particularly grateful to M. Antoine Terrasse, writer and art historian, whose expert knowledge of Bonnard's work, his enthusiasm for this project, as well as his constant and friendly assistance, made it possible for us to present these images.*

Françoise Heilbrun and Philippe Néagu

Wherever possible, the full page plates and catalogue illustrations were realized from modern prints originating from Pierre Bonnard's original negatives. These prints were made by Yvon Le Marlec, with the exception of those used for plates 61 and 81-84 which were carried out by Jean-Jacques Sauciat of the photographic laboratory of the Musée d'Orsay.

In the absence of negatives by the artist, modern prints reproducing original prints from the Bonnard archives have been used (plates 62-80 and two-thirds of the illustrations in the catalogue). This work of reproduction was carried out by Patrice Schmidt of the photographic laboratory of the Musée d'Orsay, assisted by Alexis Brandt and Jean-Paul Pinon. The modern prints used for the plates and in the exhibition have been touched up by Patrice Schmidt.

On behalf of the Musée d'Orsay, the authors would like to express their gratitude to:
Guy-Patrice Dauberville, Monsieur et Madame Prouté, Dianne Cullinane, Marie-Agnès Le Bayon, Hélène Bocard, Françoise le Coz, Michèle Rongus, Radjevi Filatriau, Sylvie Frétet, André Lejeune, André Fourcade, Laurent Stanich, B. Gaudichon, M.-A. Anquetil, Béatrice Rosenberg, Brigitte Vincens, and Françoise Garcia.

Translation by Dianne Cullinane © 1987

Preface

*The importance of a square or rectangle – of the four right angles that compose the "snapshot" –
are what determine the composition of a photograph: shadow, light, and the subject's poses all
depend on these angles for their equilibrium.*

*Unless one looks at a large expanse from a distance, the eye can only take in fragments. What
one sees in the street, in a room, in a square, in a garden, in front of a cathedral, or in a factory
are details, fragments. The apparition is created in surreptitious meeting of time and space, a
fraction of a second, a point in space. Never did the builders of cathedrals, architects, engineers
or railway pioneers, dream of the views to be captured by the instantaneous regard of a spectator.
These views are* consequences. *Thus inspired, the "shot" itself, admirable or not, is a direct
result of the visual perception of its author. Photography is an art in the degree to which the
photographer brings a new emotion to our vision and spirit.*

Pierre Bonnard insisted on man's mobile *and* changing *vision. As photographic emulsions
became more sensitive, photography was able to approximate and transcribe this vision, making
it part of the photographer's memory in an instant. Photography captures faces and objects from
life, and inscribes them on film, using light to recreate them. Its artifice is nourished on reality.
And so once the model has disappeared, the figure in the photograph acquires the value of a
resurrection. Owing to this almost magical* presence, *photography seems more suited to*

translating what is common to all people whether it is great sorrow or distress – wars, misery, hunger – or the simple splendor of living. One need only recall the photojournalism of artists such as Cartier-Bresson, Doisneau, or Brassai, in order to assert that photography has replaced painting as the translator of universal sentiments.

But only painting can give form to the world that haunts us, the world of images created in dreams, in fleeting inspiration, and in memory with all the secrets and transformations it holds. Man has always sought inspiration in this dream world: hence the winged horses of Odilon Redon, and the eerie landscapes of Gauguin – all invented forms.
Between the thought and the oeuvre, the assurance or trembling of the hand, hesitation or regret slip in...

Nothing gives a better idea of the different approaches of photography and painting than the confrontation within a painter between the photographs that he might have taken and his canvases. Bonnard's photographs confirm the marvellous freedom of his vision. Bonnard the painter, so avid for personal expression, must have been astonished by this medium that seizes the moment, arrests movement in flight, and captures everything – rooftops, foliage, children's games. Devouring its prey whole, photography gives it back intact – having first engraved upon it the sensitivity of a vision.

Photography is also a "surface plane." Along with painting, it possesses the same distance in relation to reality. Each medium lives its own life; each possesses its own magic.

Antoine Terrasse

Introduction

Until recently, very little was known about the photographic activity of Pierre Bonnard. Not only was Bonnard himself silent about this aspect of his work, but for several decades most of his photographs lay undiscovered in family archives. In the past few years, some of these photographs were included in large exhibitions examining the general relationship between painting and photography, but still, less was known of Bonnard's photography than, for instance, that of his friends Edouard Vuillard and Edgar Degas.[1] However, as a result of growing interest in photography and, in particular, its importance to Post-Impressionism, this situation has begun to change.[2] When the international exhibition *Bonnard: The Late Paintings* was organized in 1984, the catalogue included the first comprehensive study of this aspect of the artist's work, an essay by Jean-François Chevrier entitled "Bonnard and photography,"[3] despite the fact that none of Bonnard's photographs were actually shown in the exhibition.

This is the first monograph devoted to the photography of Bonnard. Together with the accompanying exhibition at the Musée d'Orsay, it offers a rare opportunity to examine this dimension of Bonnard's artistic vision. The organization, identification, and dating of so many newly discovered photographs provides a valuable comparison of Bonnard's work in this medium with his paintings and graphics, as well as offering an understanding of his skill as a photographer. Although Bonnard had no artistic ambitions as a photographer, he nevertheless demonstrated in this area the force and originality of his special powers of observation and reflection. Bonnard's photographic work goes beyond mere anecdote; these are works that have a dual interest. First, they are important for their links with the themes and formal aspects of his paintings and graphics. Secondly, they are of value for what they tell us about the practice of amateur photography in the decades around the turn of the century and, in particular, how the advent of the instantaneous photograph affected the practices of many artists and changed our ways of seeing.

Bonnard took up photography as an amateur at the beginning of the 1890s. In doing so, he followed the lead of many artists and writers in Europe, including the painters Edgar Degas, Edouard Vuillard, Henri Toulouse-Lautrec, Edvard Munch, and Georg Breitner, and the writers Emile

(1) Erika Billeter, ed., *Malerei und Photographie im Dialog, von 1840 bis heute*, (Zurich: Kunsthaus, 1977; Bern: Benteli, 1979).
(2) See p. 146 for a list of Bonnard photographs previously published.
(3) Jean-François Chevrier, "Bonnard and photography," in *Bonnard: The Late Paintings*, ed. Sasha M. Newman (Paris: Musée National d'Art Moderne; Washington, D.C.: The Phillips Collection; Dallas: The Dallas Museum of Art, 1984), pp. 83-104.

Zola and August Strindberg. By the 1880s, the techniques of photography had become so simplified that the medium was accessible to practically everyone. Cameras were smaller and lighter, negatives were industrially prepared and developed, and previously prolonged pose-times had been cut to an incredible one-fiftieth of a second. Leading this revolution was the ubiquitous Kodak portable camera, introduced in 1888, which produced small negatives on pliable film and permitted instantaneous snapshots. This instantaneity, in particular, interested many artists, including Bonnard and Vuillard. (While Degas, who had been taking photographs since 1884 and was interested in momentariness, had a rather different approach. Even in the 1890s, Degas still used a tripod and glass-plate negatives in strongly lit interiors, preferring to decompose movement into a language of poses and then copy them on film.)

It is easy to understand why Bonnard and Vuillard were fascinated by snapshots. Their paintings and prints of this period depict the most fleeting moments of everyday life. Bonnard's special ability to capture the details of daily life and to imbue them with the sublime, led André Lhote to describe him as a "celestial reporter."[4] Bonnard himself observed that "The most important thing is to remember what most impressed you and to note it down as quickly as possible."[5] This combination of insight and quick reporting characterizes Bonnard's paintings and his photography.

On a broader, social level, all of the Nabis – including Maurice Denis, Ker-Xavier Roussel, and Toulouse-Lautrec, as well as Vuillard and Bonnard – consciously strove to apply their talents to the production of useful objects. Their belief in popular production, socialized practice, and the creation of an art for everyday use was derived in part from the then-popular Art Nouveau. But for the Nabis, this commitment manifested itself in a rigorous investigation of techniques of design and interior decoration, often only marginally related to painting and sculpture.[6] Having established their interests in printmaking, poster design, stained glass, and furniture production, it was perhaps natural for these artists to recognize the popular potential of photography.

Thus, Bonnard was not just a talented amateur photographer who took an interest in the camera merely to record fleeting moments of his private life. For any artist, his or her private life is also the subject matter of his or her art. This is especially true for Bonnard whose subjects were very much determined by his environment. Bonnard did not use his photographs as literal sources for his paintings, but rather as a type of notation. Photography was, for Bonnard, an artistic exercise – like drawing. For, as Bonnard noted, "Drawing represents feeling; color, judgment."[7]

Bonnard's first known photograph is an image of his cousin, Berthe Schaedlin, taken in the early 1890s (cat. no. 1). There is then a large gap separating this early effort from the rest of his photographic work, which began to take shape only in 1898. Bonnard must have taken other photographs, but perhaps he was dissatisfied with his early attempts in the new medium and kept only those with sentimental value.[8] Or, perhaps the majority of Bonnard's early photographs were simply lost during the many moves that he made at that time. Whatever the case, it seems surprising that, given the advantages of instantaneous photography, Bonnard, whose principal subject was Parisian life, never photographed in the streets like Emile Zola, Henri Rivière, and many other amateur photographers. Bonnard almost never photographed outside his immediate circle. Apart from a few anonymous models photographed in his studio in 1905 and 1916 (see chaps. 21 and 26), all of Bonnard's photographs are set amongst family and friends. After a period of intense photographic activity from 1898 to 1905, Bonnard's interest seems to have dissipated; after 1905, his photographs changed and he took them less frequently (though, again, many may have been lost). Bonnard abandoned photography around 1920, at the same time as many other amateurs who had taken up photography in the 1890s.

How did Bonnard begin taking photographs? Was Vuillard responsible for his friend's early interest? Clearly, Vuillard was a much more avid photographer than Bonnard, developing his own negatives and even involving his mother in the printing, but his influence on Bonnard is uncertain.[9] Nor can one say that Degas's photography incited Bonnard, since Degas's influence only manifested itself in Bonnard's work after 1900. A third possibility is that Bonnard was influenced by the Lumière brothers, inventors of the autochrome and pioneers of the early cinema. Through his brother-in-law, Claude Terrasse, Bonnard was acquainted with Auguste and Louis Lumière and they were frequent guests at the family property at Grand-Lemps. Yet, the fact is that Bonnard began photographing at a moment when the popularity of the Kodak was so great that it was hardly necessary to have such luminous patrons for incentive. Rather, as Bonnard's close friend Thadée Natanson suggested in a letter to Stephane Mallarmé, cameras were *de rigueur*. Written during a stay at Etretats-les-Mauves in the summer of 1894, Natanson's letter recalls the family gatherings typical of Bonnard's paintings and photographs: "Only a few tiny tots and two or three famous, elaborately dressed bathing beauties put in a conspicuous appearance, jump onto the pebbled beach, dive into the water, or shake themselves dry, to the joy of the well-dressed women who

(4) André Lhote, "Bonnard," *Formes et Couleurs* (Paris) 6 ann., no. 2 (1944): 10.

(5) Notation by Bonnard, in *Pierre Bonnard: dessins et aquarelles* (Paris: Galerie Claude Bernard, 1977), p. [1].

(6) Claire Frèches-Thory, "Bonnard nabi," in *Hommage à Bonnard* (Bordeaux: Galerie des Beaux-Arts, 1986), p. 23. The author insists on this aspect of Nabi art without mentioning photography.

(7) Notation by Bonnard, in Antoine Terrasse, "Bonnard's notes," in *Bonnard: The Late Paintings*, p. 52.

(8) It is possible that the two photographs of a cat taken at Grand-Lemps (cat. nos. 42 and 43) were also taken before 1898.

(9) Jacques Salomon, "Vuillard et son Kodak," *L'Oeil* (Paris), no. 100 (April 1963): 15.

come to see the show. Kodaks of all models swallow with a little dry click the latest fashions to be admired." [10]

Given the popularity of photography in Bonnard's circle, it may seem surprising that no mention was made of his pictures until the late 1970s, whereas Degas's photographs were well-known to his contemporaries. Bonnard's photographic œuvre is no less interesting than Degas's, despite the dramatic impact of the rather complicated poses that Degas required of his models. But Degas attached greater importance to his photographs, going to the trouble of having enlargements made by Tasset so that he could offer them to his friends. Bonnard, on the other hand, does not seem to have made any attempt to print his own negatives, make enlargements, supervise the development or printing processes, or to make this production a family affair as did Vuillard. [11] Moreover, Bonnard, who was hardly generous with confidences on his work as a painter (which were generally reserved for his personal notebooks, of which only those from 1927-47 survive – in other words, well after he had given up photography), was even more sparing in his remarks on photography. Even though photography formed a real part of his work from 1898 to 1916, Bonnard seems always to have regarded it as secondary.

Vuillard also seems to have attached little importance to the artistic value of his remarkable photographs. He did, however, show somewhat more interest in this pastime than the discrete Bonnard (without going so far as Zola, who said that the only things one sees well are what one photographs, [12] or Strindberg, who wanted to have all his photographs published) [13]. Vuillard's interest was substantial enough that, when the first article on his photographs was published in 1963, his friends Jacques Salomon and Annette Vaillant were able to recall his pointed positions on the subject of photography. It is precisely in this context, in an article entitled "Vuillard et son Kodak," that Salomon relates the only known thoughts of Bonnard pertaining to photography: "One morning when I was telling Vuillard of a conversation I had had recently with Bonnard on the subject of color photography, the results of which seemed to have excited and even disturbed him, Vuillard, who knew how paradoxical his friend liked to appear, continued to work on a painting and replied that painting would always have the advantage over photography of being done by hand." [14] It is uncertain how Bonnard's disturbed reaction – no doubt dating from the 1920s or 1930s – should be interpreted. Was it an exaggeration or was Bonnard serious?

Around 1898, Bonnard began to develop real finesse as a photographer. It was not that he developed greater skill at processing or printing, since these mechanical aspects of photographic production never really interested him. Rather, it was that he had simply achieved a technical mastery sufficient to allow his personal artistic vision (already evident in his paintings) to be fully expressed. It is this sophisticated exercise of artistry and vision that distinguishes Bonnard's snapshots from those of thousands of other contemporary amateur photographers.

Bonnard's early efforts at photography were tentative, sometimes clumsy. So even his charming, somewhat pictorial, photograph of Berthe Schaedlin (cat. no. 1) is considerably less bold than the inventive arabesques of Bonnard's contemporaneous paintings *Les Femmes au jardin* or *La Partie de croquet* (despite the fact that all use the same model at the same time). Similarly, the touching, but rather stiff, snapshot of the three Terrasse children in the dining room (cat. no. 2) cannot compare with the marvellous series of children at table painted by Bonnard from 1894 to 1899. [15] However, beginning in 1898-99, with a series of photographs of Madame Mertzdorff and her grandchildren at Noisy-le-Grand (cat. nos. 3-38), Bonnard's photographs show a noticeable authority in the poses and in the treatment of light; this enables one to speak of a true photographic style distinctive to his work. There is a very strong relationship between his way of seeing the world and his style that unifies his work in all mediums: photographs, paintings, drawings, and engravings.

This interrelationship is manifested first of all in the themes developed by the artist. As a general rule, Bonnard's favorite themes, both in photography and in painting, are those dealing with everyday life: interiors, family scenes, bathers, table settings. From 1907 onward these mundane themes were given a cosmic character in his canvases. On the other hand, certain domains typical of Bonnard's painting were practically untouched in his photography. Landscapes, for example, are often present in the photographs, but they play a secondary role as a setting or background; still lives are entirely absent. The fact is, however, that pure landscapes (or still lives) were relatively rare subjects for Bonnard during his Nabi period, although they became the favorite themes of his maturity. The formal portrait is also rare among the many photographs that Bonnard took of his family, friends, and himself. This is true of his paintings as well, with the notable exception of a few moving self-portraits. For the most part, Bonnard did not seek to express the individual personalities of his subjects by examining their facial expressions or by faithfully reproducing their features. Rather, he sought to capture their "souls" by watching the liveliness of their gestures, the grace of their movements, and the sensuality of their poses. For Bonnard, as for Proust, an individual was the sum of different "appearances." And the photograph served primarily as a recorder of these protean appearances.

The scarcity of interior scenes in Bonnard's photographs is no doubt due to purely technical restrictions. Certainly Bonnard did not want to yield to the same com-

(10) Cited in Arthur Gold and Robert Fitzdale, *Misia: The Life of Misia Sert* (New York: Alfred A. Knopf, Inc., 1980), p. 55.

(11) The family has kept several Kodak development envelopes that still contain nude photographs of Marthe.

(12) Interview with Emile Zola, *Photominiature* (Paris), no. 21 (December 1900): 396.

(13) Stockholm Kulturerhufet, *Strindberg*, exh. cat., May 14-October 4, 1981. Text by Göran Söderström.

(14) Salomon, "Vuillard et son Kodak," p. 19.

(15) Cf., D.69, D.106, D.177, and D.206.

promises as Degas who, because of weak interior lighting, was forced to "organize the instant." On the contrary, Bonnard insisted on being able to capture the instant in complete freedom. This perhaps explains the fact that one of Bonnard's favorite subjects in painting – scenes around a table – appears in only one photograph and, ironically, that one was taken out of doors (cat. no. 99). Vuillard, on the other hand, was able to circumvent many of the technical problems posed by artificial lighting and his photographic œuvre contains a large number of interior scenes. But Vuillard's photographs are more static than those by Bonnard, and, like Degas, Vuillard compensated for the absence of real movement in his images by the dynamism of his layouts. Bonnard's most captivating instantaneous snapshots were all taken outdoors.

From 1899 onward, Bonnard's photographs treat the same subjects as his paintings: family scenes at Grand-Lemps or intimate scenes connected with leisure activities. Scenes of Terrasse children playing in the pools at Grand Lemps appear in fifteen photographs and at least three canvases from 1899 (see chap. 5). A series of photographs showing fruit-picking in the garden of the "Clos" was also the subject of three paintings by Bonnard (see chap. 8). But it is above all in the series of nudes of his companion Marthe (taken both indoors and outside) from this period that Bonnard achieved a true symbiosis between photography and printmaking (see chaps. 11 and 12). This particular dependence on photographs as a source is rather exceptional, for, on the whole, his compositions are not repeated from one medium to another – especially from photography to painting. Nevertheless, Bonnard's works in various mediums often originated from the same sentiment or from his fascination for a theme whose formal expression he then enjoyed renewing indefinitely in different forms. For example, following his cruise on Misia and Alfred Edward's yacht *Aimée* in 1906, Bonnard brought back a sketchbook of drawings and a series of snapshots (see chap. 23) that do not appear as motifs in any of his paintings of the trip (pl. XIV). Similarly, the painting of a model in his studio from around 1916 is very different in pose and composition than the four photographic studies of her taken at about the same time (see chap. 26). In the painting, Bonnard concentrated on the figure, whereas the photographs emphasize the geometric frame that hugs the silhouette, according to a schema he frequently used in other paintings.

Bonnard was too much of a painter to yield to a systematic use of photography. Rather, his photography was a parallel activity developed at the same time as his drawing and painting. Even during his Nabi period, when he produced the majority of his photographs, Bonnard painted many subjects that he never photographed. But Bonnard also took many photographs whose abundant formal discoveries he never attempted to use in his painting. Of the series of photographs from Noisy-le-Grand (see chap. 3), for example, only four or five images are related to paintings; this is true also for the extraordinary snapshots of children playing in a pool from 1903 (see chap. 19).

Although Bonnard generally refused to use elements from his photographs in his painted work, there are some important exceptions that demonstrate that he not only looked at his own photographs, but that he sometimes integrated parts of them into his work as a painter and illustrator. The painting *Les trois enfants nus,* 1899 (D. 194; fig. 3), which seems more like a study than a finished composition, is clearly related to three photographs taken at Noisy-le-Grand in 1898 or 1899 (cat. no. 26 and, in particular, nos. 25 and 27); these show Bonnard's nephews Charles, Robert, and Jean Terrasse dancing in a circle. The only motif retained by the artist was the nude dancers against the background of the lawn. Bonnard combined and transformed the succeeding poses of the dancing silhouettes in order to obtain a unique image that is both close to and different from the photograph. This presents a very good example of the precise process by which Bonnard recorded instantaneity in his paintings.

Unlike the Impressionists, Bonnard did not paint in the open air. Rather, as André Lhote remarked in 1944, "memory played a fundamental role, and the vision of the world, no matter how dazzling, was interiorized and sometimes intellectualized. [Bonnard] performed a sort of *decanting of the memory* – to repeat Jean Clair's handsome phrase." [16] Clair used this phrase to compare Bonnard and Marcel Proust's uses of memory: "... Bonnard's intention, which, since he was defenseless in the presence of the subject, consisted in letting himself be imbued with it, only to revive it later on." [17] Another example of the importance of memory to Bonnard is the book published by Tériade in 1944 in which Bonnard wrote a series of fictitious letters concerning events that had taken place more than fifty years earlier (see chaps. 5 and 8).

In a series of nude paintings of Marthe from 1900 (pl. X), Bonnard assimilated and interiorized motifs from the intimate photographs that were themselves impregnated with his vision as a painter. The marvellous photograph of Marthe sponging herself in a tub (cat. no. 214; pl. 59), from 1907-10, is along with the sketches of nudes in tubs from 1912, part of the history of seven canvases of the same theme that were painted between 1913 and 1924 (see chap. 24). These paintings leave no doubt that the photograph served as a principal reference for Bonnard's imagination. Each painting presents at least one characteristic analogy with the photograph: either in the construction of the whole (cf., *Nu au tub,* c. 1916, D.02105; pl. XV) or in a very precise detail, such as the gesture of an arm, the position of a leg, or the raised tip of a breast (cf., in particular, D.886, D.02130, and D.02131.)

That Bonnard sometimes used the photograph as a sketch or study can be understood from the prints in which he literally repeated the subjects of certain photographs (something he was usually careful to avoid in his paintings).

(16) Philippe Le Leysour, "Sur Bonnard: Propos et critiques," in *Hommage à Bonnard* (Bordeaux: Galerie des Beaux Arts, 1986), p. 31.
(17) Jean Clair, "The adventures of the optic nerve," in *Bonnard: The Late Paintings,* p. 31.

For example, the cover that he designed in 1902 for René Boyesve's book, *La Leçon d'Amour dans un parc* (pl. VI), portrays his nephew, Charles Terrasse, exactly as he was captured in a photograph of 1899 (cat. no. 55; pl. 72). Bonnard simply changed the context (Charles becomes a cupid decorating a fountain) and modified the gesture of an arm (which is less provocative than in the photograph).

Evidence of the most insistent and numerous analogies between Bonnard's photography and his graphics is found in his lithographs illustrating Paul Verlaine's *Parallèlement* and Longus's *Daphnis et Chloé*, commissioned by Ambroise Vollard and carried out between 1899 and 1902. For the illustration of the moment that Chloë first appears nude before Daphnis (pl. IV), Bonnard copied directly, without variation (for the only time), from a photograph of Marthe taken in 1900 in the garden at Montval (cat. no. 129; pl. 5). Bonnard himself served as a model for a photograph taken by Marthe during the same session. In the illustrations, the artist appears (with some slight variations) as Daphnis – crowned with violets by Chloë (for, pl. 15 and pl. V) and holding up a goatskin in honor of Pan (fig. 10). The plate showing Lyceneus initiating Daphnis to the rites of love (fig. 11) is inspired directly by a nude of Marthe posing on her bed (cat. no. 115), one of a series of nudes taken in Bonnard's Parisian apartment in 1899-1900 (see chap. 11). This series of nudes also served as the principal source for Bonnard's illustrations of *Parallèlement*.

The lithograph depicting the young woman in "Limbes" from Verlaine's poem *Parallèlement* (pl. II) combines two photographs of Marthe: in one she is leaning on her elbows contemplating her body (cat. no. 108; pl. 17) and in the other she is hugging her bended knees (cat. no. 109). Marthe also served as the model for the prints of "Eté" (pl. III) and "Allegory"; in the photograph she appears seated, with her back to the camera (cat. no. 112; pl. 16). The nudes taken in an interior can be dated on the basis of the lithographs for *Parallèlement*, which we know he "hammered away" at in 1899.[18] The nudes in the garden at Montval can be dated with certainty during 1900-01 (see chap. 12), that is, after Bonnard had received the commission for *Daphnis et Chloé* in September 1900.[19] It is therefore possible that Bonnard carried out this series of nudes with the illustrations for *Daphnis et Chloé* in mind. In any case, in the period 1899-1900, when Bonnard painted his most sensuous nudes and took his most tender photographs, there seems to be a definite interpenetration between his private life and his work. The artist himself confirmed this when he recalled later, "On each page I evoked the shepherd of Lesbos with a sort of happy intoxication that quite carried me away."[20] Ironically, of the intimate images of 1900, evoking the same voluptuous and langorous atmosphere, it is the nude photographs that display the greatest modesty, reserve, and mystery. By contrast, when using more removed techniques, like painting or illustration, Bonnard did not hesitate to charge his nudes with a much more intense eroticism (see pls. IX and X).

"One always talks of surrendering to nature. There is also such a thing as surrendering to the picture."[21]

"Observe nature, and work on the canvas, indicating the colors: the climate of the work transcends all else."[22]

"Untruth is cutting out a piece of nature and copying it."[23]

"Harmony is a more solid foundation than observation, which can so easily be wrong."[24]

These remarkable observations concerning painting that Bonnard jotted down in his notebooks might also apply to the way in which he conceived his photographs. For even though his photographs are essentially snapshots, taken on the spot, they obey certain harmonic laws and were instinctively constructed according to the artist's vision. Bonnard waited for what Henri Cartier-Bresson later called the "decisive moment," that flash when form and expression combine perfectly within the same image. Whether it is Andrée Terrasse playing with her infants, the children coming out of a pool, or the family gathering fruit, all the figures in Bonnard's photographs seem to naturally execute the same sinuous, decorative ballet that characterizes his Nabi canvases such as *La Partie de croquet*, 1892 (D.38), *Femmes au jardin*, 1891 (D.01716), or *La Femme à l'ombrelle*, 1894 (D.51). Even the wrestling matches between Claude Terrasse and his friend Henri Jacotot, are treated as a succession of arabesques (cat. nos. 180 and 181; pls. 64 and 65). In the series of nudes in the garden at Montval (cat. nos. 118-135; pls. 1-11), there is an almost melodic continuity from one image to the next, as if the entire series had been conceived as a single lyrical composition. Finally, we might look again at what appears to be a very simple and straightforward photograph of Andrée Terrasse playing with the family pets (cat. no. 4; pl. 19). In fact, this photograph captures an animated scene that is swarming with little "events": the extraordinary sight of the cat climbing up Andrée's dress, the delighted little girl in the large hat with her fingers in her mouth (typically Nabi in spirit), and the ravishing detail, in the foreground, of the standoff between the cat and dog – in shadowgraph.

Obviously, Bonnard's photographic eye derived from his vision as a painter, since this had already been formed before he began to take photographs. From studying Japanese prints, for instance, he inherited the humorous and very expressive manner of sketching the silhouette in a flat decorative way. This then allowed him to portray Mme

(18) Letter from Bonnard to his mother, Autumn 1899. Cited in Antoine Terrasse, "Chronology," in *Bonnard: The Late Paintings*, p. 248.

(19) Chevrier, "Bonnard and Photography," p. 100, dates these nude photographs 1894, the year that Bonnard first met Marthe.

(20) Quoted by Marguette Bouvier, "Pierre Bonnard revient à la litho...," *Comoedia* (Paris), no. 82 (January 23, 1943).

(21) Notation by Bonnard, February 8, 1939, in Terrasse, "Bonnard's notes," p. 70.

(22) Notation by Bonnard, February 14, 1939, ibid.

(23) Notation by Bonnard, January 22, 1934, ibid., p. 69.

(24) Notation by Bonnard in a sketchbook. Quoted in Jean Leymarie, *Bonnard et sa lumière* (Paris: Maeght Editeurs, 1978), p. 26.

Mertzdorff seated in the garden (cat. nos. 7 and 8; pls. 20 and 21) as a large, dark, formless patch. The lovely plastic effect created echoes Bonnard's own paintings from eight years earlier, such as *La Provende des Poules,* 1892 (D.01725) or *La Grand-mère aux poules,* 1890 (D.11).

One essential aspect of Bonnard's pictorial vision was his ability to change everyday moments into poetic marvels. In the series of nudes of Marthe and himself which seems to be set in the woods, Bonnard has conferred the mysterious grace of a mythological landscape upon the garden at Montval (normally the scene of mundane bourgeoise pastimes). This effect was created simply by contrasting the luminous body with the shadows cast by the foliage and by capturing silhouettes from the distance and enveloping them in a sort of halo. Marthe's natural delicacy must have aided Bonnard in this effect, but it is clear that perceptions of her depend on Bonnard's interpretation, for in other shots she seems to present a very different image, solid and strongly plastic (cat. no. 120; pl. 3).

Although Bonnard often used distance to make his figures appear lighter, in his photographs as in his paintings, he also used the opposite process: the close-up. These close-ups create compositions that seem most typical of instant photography, compositions in which the centralized vision belonging to Western perspective is practically obliterated. Close-ups appear in Bonnard's paintings and prints from about 1890 onward, and in his photographs after 1898. A constructive device which Bonnard never abandoned, close-ups are an element of continuity between his early and late "styles" in painting, and his photography (pls. 25, 52, and 53). The use of close-ups contributes to the volatility and softness in the outlines of figures, qualities that are characteristic of Bonnard's pictorial and photographic vision.

The kinship of vision and style is so strong in Bonnard's paintings, prints, and photographs, that it is possible to follow in his photography the same evolution that characterizes his art: the passage, around 1907-08, from a graphic, decorative Nabi style to a more monumental, plastic style. Bonnard's early taste for linearity and arabesques gives way to a more rigorous concern with construction, which is distinquished by a new approach to light. In this development, the photograph of Marthe sponging herself in a tub (c. 1908) is a turning point (cat. no. 214; pl. 59). By this time, Bonnard had switched to a different format camera; the negatives are larger and are generally vertical rather than horizontal. This new format reflects his search for a new type of image – one that is more static and in which volumes are more strongly marked (as opposed to his Nabi period when silhouettes were flatly detached from contrasting backgrounds).

Bonnard seems to have abandoned photography shortly before 1920, but, judging from the surviving photographs, his interests in this area had already begun to diminish in 1908, or, at the very moment when he became essentially a painter of color. If, after 1920, one no longer finds the same specific links between his paintings and earlier photographs, his experiments in photography seem

to have affected his art in a new and very characteristic manner: in the way he conceived space in his paintings. In his analysis of Bonnard's very original conception of perspective, Jean Clair was the first to suggest that in his practice of photography "[Bonnard] had reflected on the way in which images come to us and take shape before our eyes." [25] Wanting to show "'what one sees when one enters a room all of a sudden,'" [26] Bonnard was particularly interested in snapshots, which shattered the rules of traditional perspective and created a subjective space where, instead of looking on from a distance, the artist and spectator are solidly tied to the center. This explains the early empty plans, stretched out disproportionately, where figures are cropped in the foreground; these are found frequently in Bonnard's photographs and paintings after 1907. Paintings such as *Jeunes femmes au jardin (or La Nappe rayée)* 1821-23, retouched and finished in 1945-46 (D.1103); *Le Grand Nu bleu,* 1924 (D.1272); and *La Table,* 1925 (D.1310) are examples of this device.

Cezanne and Degas undoubtedly provided the models for Bonnard's radical reevaluation of perspective, but for them the perception of space was subjective and expressed a conscious vision. Bonnard wanted to go further: to express an unconscious vision, a "visual entirety" in which all perspective hierarchies would be abolished. [27] As he observed in his notes, "A strict compartmentalizing of one's vision nearly always produces something false. The second stage of composition involves integrating certain elements which are outside that rectangle." [28] So, the deformation of photographic images – or perhaps cinematic effects [29] – provided Bonnard with a means for representing this perspectival upheaval. The elongated body of a dog walking directly toward the camera (cat. no. 23; pl. 23), the gigantic proportions created by a close-up of Robert Terrasse marching by (cat. no. 18; pl. 25), or the cropped figures which seem to literally frame certain outdoor scenes (cat. nos. 49 and 105, pls. 32 and 43), all evoke the seemingly arbitrary placement of subjects in Bonnard's subsequent paintings. Figures are cut up, deformed, or relegated to the corners in such compositions as *En barque* c. 1907 (D.463); *La Loge,* 1908 (D.496); *La Fenêtre ouverte,* 1921 (D.1062); *Nu violet,* c. 1925 (D.1473), or *Salle à manger sur le jardin,* 1931-32 (D.1336). In certain photographs of Renée and Charles Terrasse (cat. nos. 169 and 170; pls. 75 and 76), the faces, so near, loom out at the spectator and are rendered amorphous by their proximity. The exaggeration of the close-up is a perfect symbol of Bonnard's fascination and defenselessness in the presence of the subject, responses

(25) Clair, "The adventures of the optic nerve," p. 37.
(26) Ibid., p. 32.
(27) For the concept of the "visual entirety," see ibid. For the concept of "unconscious vision" (an idea of Jean Clair's), see Le Leysour, "Sur Bonnard," p. 33.
(28) Notation by Bonnard, October 12, 1935, in Terrasse, "Bonnard's notes," p. 69.
(29) Chevrier, "Bonnard and photography," p. 104, speaks of the probable influence of the first films of the Lumière brothers on Bonnard's photography.

which led him to dissolve reality in order to reproduce it.[30]

The importance of Bonnard's photographs is not limited to their relationship to his paintings and illustrations. His photographs also have an existence and impact of their own; this is not due merely to chance. For, although Bonnard always refused to consider himself as a photographer or to develop his technical expertise, the strength and originality of his vision are enough to compel recognition of his photographic oeuvre.

It is interesting to compare Bonnard's photographs with other contemporary masters of the instant photograph, such as Vuillard, a remarkable photographer whose works have still not received due consideration. Like Bonnard, Vuillard had no aesthetic ambitions in this field, but his technical ability was considerably superior. His subjects were identical to those of Bonnard, his compositions were always wonderfully constructed, and he was adept at describing the charm and drollness of everyday moments – like the pure rapture of the little girl being tickled by Bonnard (cat. no. app. 2; pl. XVI, top). Nonetheless, his photographs lack the pure sculptural fantasy and genius that enriched his paintings of this period. Or, to take another example, the photographs of the printmaker Henri Rivière[31] show that he was just as efficient as Vuillard or Bonnard in interpreting instant photography, and even more subtle. Yet, his works do not have the inventiveness in the plastic expression that one finds in Bonnard's most daring images. Setting aside the obvious difference in technical abilities, it is the early work of Alfred Stieglitz that provides the closest equivalent to the type of research and experimentation in instant photography that Bonnard's photography exemplifies. Stieglitz represents the most noble category of amateur photographer: the insightful artist rather than the merely skillful camera operator.

The most famous amateur photographer, Jacques-Henri Lartigue, belonged to the generation following Bonnard's and took up photography a decade later. Although Lartigue was an amateur, unlike Bonnard, he photographed with passion throughout his life.[32] Lartigue's technical skills were superior to Bonnard's, but he did not have the faultless technical facility of Stieglitz. An enthusiastic observer of modern life, Lartigue stressed in his photographs movement, speed, sport, and a fascination with the fashionable life. Among his other attributes, Lartigue possessed a sure eye, a sense of humor equal to Bonnard's, confidence in the graphic harmony of his daring compositions, tenderness in his intimate photographs, and insight in his depiction of social life. Yet, Lartigue's photography is less mysteriously poetical than Bonnard's and his vivid wonder in the face of the world's beauty is more limited in its plastic expression. One will search in vain among Lartigue's images for an equivalent to Bonnard's magnificent studies in light and chiaroscuro, works such as the monumental photograph of a gathering in Bonnard's studio (cat. no. 169; pl. 74), or the almost abstract composition of mellow sensuality that is created by the shadows of foliage reflected on the whiteness of a dress or face (cat. nos. 8 and 80; pls. 21 and 31, and see chap. 8).

Bonnard owes the infinite wealth and depth of his photographic vision to his great qualities as a painter. Had he chosen to practice photography seriously, his work would have made the imaginations of the greatest "pictorialists" seem dull. But it was precisely because he was above all a painter that Bonnard did not attempt to go further in photography, an art whose exercise is just as demanding and as exclusive as painting and therefore often incompatible with it. Several of Bonnard's photographs, not directly related to his paintings, show that if he had wanted to, he could have been among the greatest photographers. Images like that of Robert Terrasse walking in front of the house at Noisy-le-Grand (pl. 25), or the scenes of children paddling in the pool at Grand-Lemps in 1903 (cat. nos. 186 and 187; pls. 52 and 53) are without precedent in the photography of that period and anticipate the art of Cartier-Bresson.[33]

However, the most indubitable testimony to Bonnard's potential as a photographer is certainly the photograph of 1899-1900 showing Marthe removing her nightgown (pl. 3). This graceful and mysterious image, whose composition exhibits an extraordinary plastic force, demonstrates Bonnard's masterful understanding of photographic language both in the subtle treatment of light and in the contrast between different materials – flesh, cloth, and bark – each rendered with all the wealth and brilliance of its texture.

(30) Le Leysour, "Sur Bonnard," pp. 32-33.
(31) An exhibition of Henri Rivière's prints and photographs will be held at the Musée d'Orsay, Paris, in 1988.
(32) Lartigue produced at least 250,000 negatives in his lifetime.
(33) Cartier-Bresson is a great admirer of Bonnard, the painter.

Characters appearing in the photographs

The order of the presentation of characters is as follows: the Bonnard family, Terrasse family, painters, and friends of the artist. Since a large number of Bonnard's photographs were of his sister Andrée Terrasse's children, we have given exact birth dates, as the children's ages constitute an element of reference in the chronology of the images.

Madame Frédéric MERTZDORFF (1812-1900).
Bonnard's maternal grandmother, she appeared very often in his paintings during the decade between 1890 and 1900.

Madame Eugène BONNARD, née Elisabeth MERTZDORFF (1840-1919). Mother of Pierre, Andrée, and Charles Bonnard. As she detested having her picture taken she rarely appears in her son's photographs. Her husband, the artist's father, died in 1895 and therefore does not appear in the photographs.

Pierre BONNARD (1867-1947).
Painter and engraver.

Marthe BONNARD, née Maria Boursin (1869-1942).
Bonnard's wife and lifelong companion. He met her in 1893, but they were not married until 1925. Marthe was the artist's favorite model and appeared in numerous nudes. She can also be recognized in several portraits and compositions.

Charles BONNARD (1864-1941).
Pierre Bonnard's elder brother, Charles, was a chemist and oenologist. He also invented several different perfumes; Pierre even designed a poster for one of his perfumes reproduced in Thadée Natanson's *Bonnard que je propose*.

Madame Charles BONNARD, née Eugénie PAOLETTI.
Eugénie and Charles were married in 1900 and had two children, Frédéric and Madeleine.

Frédéric BONNARD.
Son of Charles and Eugénie Bonnard.

Madeleine BONNARD.
Daughter of Charles and Eugénie Bonnard.

Berthe SCHAEDLIN.
Pierre Bonnard's cousin who he once thought of marrying and who is represented in several canvases of his youth (see Chapter 1).

Claude TERRASSE (1867-1923).
Terrasse married Andrée Bonnard at Grand-Lemps on September 25, 1890. He was a composer and music teacher, first at Arcachon and later in Paris where he moved with his family in 1896. As a pianist he participated in a group that included Jacques Thibaud and André Hekking. In 1897, he set up the "Petit Théâtre des Pantins" with Alfred Jarry and Franc-Nohain in a studio next to his apartment at 6, rue Ballu. Claude Terrasse wrote *Petit solfège illustré* and composed a work of great charm called *Petites scènes familières*, for which Bonnard carried out a series of illustrations 1892-1895. In 1901, Terrasse collaborated with Bonnard and Jarry on the *Almanach illustré du Père Ubu*, published by Vollard. He composed a number of lyric operas such as *Monsieur de la Palisse*, *Le Sire de Vergy*, *Le Mariage de Télémaque*, and *La Petite Femme de Lotte*. In his *Notes et contre-notes*, Claude Debussy spoke of Terrasse's music with high praise.

Andrée Bonnard TERRASSE (1872-1923).
The artist's younger sister. An excellent musician, Andrée married the composer Claude Terrasse in 1890; they had six children. She appears frequently in the artist's paintings during his Nabi period, and she can also be seen in numerous photographs along with her children. In *L'Après-midi bourgeoise* (plate XII), Bonnard represented her at the left of the canvas.

Jean TERRASSE (May 6, 1892-1932).
First child of Andrée and Claude Terrasse. He was a lung specialist and, along with Dr Francis Tobé, founded the sanatorium of Sancellemoz in the Haute-Savoie.

Charles TERRASSE (October 1, 1893-1982).
Second child of Andrée and Claude Terrasse. Archivist and paleologist, he was curator-in-chief of the National Museums and carried out his functions at the Château de Fontainebleau. Charles Terrasse published a number of books on art history including *French Renaissance Paintings in the Louvre*, *Renaissance Architecture in Lombardy*, *Art from the Chateaux of the Loire*, *Sodoma*, *Germain Pilon*. He also wrote an important study of *François I* and the *History of Art, from its origins to Today* (3 vol., 1938-46). Charles was fascinated by Bonnard's art and was often his uncle's confidante. He wrote several studies on Bonnard, including an important monograph that was published by Henri Floury in 1927 on which Bonnard himself collaborated.

Renée TERRASSE (December 5, 1894-1985).
Third child of Andrée and Charles Terrasse. Renée was secretary at the publishers Bernard Grasset. In 1945, after the death of Marthe, she gave up her professional activities to look after Pierre Bonnard.

Robert TERRASSE (June 24, 1896-1966).
Fourth child of Andrée and Charles Terrasse. Robert became an administrator in the Overseas French Territories.

Marcel TERRASSE (1897-1898).
Fifth child of Andrée and Claude Terrasse. He died at the age of a year-and-a-half.

Eugénie « Vivette » TERRASSE (April 11, 1899).
Sixth child of Andrée and Claude Terrasse. She became the wife of the art book publisher Jean Floury, the son of publisher Henri Floury.

Auguste PRUDHOMME.
Archivist in the Isère department, he was Charles Terrasse's godfather. Bonnard portrayed him in profile in *L'Après-midi bourgeoise*, 1900 (plate XII).

Madame PRUDHOMME.
Charles Terrasse's godmother, she also appears in Bonnard's canvas *L'Après-midi bourgeoise* (seated at the center with her face raised toward her godson).

Doctor GUILLERMIN.
Terrasse Family doctor at Grand-Lemps.

Henri JACOTOT.

Singer and songwriter, Jacotot was a close friend of Claude Terrasse whom he visited at Grand-Lemps. Bonnard took a series of photographs of him clowning with Terrasse during one of his visits (see chap. 17).

Edouard VUILLARD (1868-1940).

Painter and printmaker. Vuillard was encouraged by his childhood friend, Ker-Xavier Roussel, to take up painting in 1887. Along with Bonnard and Roussel, he first gained recognition with the Nabis, a group formed in 1888 to defend the aesthetics of Gauguin. The three artists remained close friends throughout their lives even though over the years their artistic approaches diverged. They traveled together to the lakes of Northern Italy and to Venice (chap. 7), and vacationed together at Grand-Lemps (chap. 10). Bonnard and Vuillard also traveled to Spain (chap. 13) and Hamburg (where Bonnard did not take any photographs).
Octave Mirabeau wrote of the ties that united these artists, "Their friendship was a joy and at the same time an advantage. For I learned a lot, even in relation to my work. They opened up a world that until then had been somewhat closed or obscure. They added more valid, healthy and ideal reasons to the taste I had for life and to the taste I had for taking pleasure in life."

Ker-Xavier ROUSSEL (1867-1944).

Painter and printmaker. He was not only joined by friendship with Vuillard; in 1893, he married Vuillard's sister, Marie. The Roussels had a son, Jacques, and a daughter, Annette, later Annette Vaillant, whom Vuillard portrayed many times in his paintings.

Claude MONET (1840-1926).

Impressionist painter and neighbor of Bonnard who visited him during his stay at Vernon (chap. 25).

Auguste RENOIR (1841-1919) and his son Jean (1894-1979).

Impressionist painter admired by Bonnard, and his son who later became a distinguished filmmaker (chap. 27).

Thadée NATANSON (1868-1951).

Along with his brothers Alfred and Alexander, Natanson founded *La Revue Blanche* (1899-1903), the principal voice of the artistic and literary avant-garde at the end of the century. He collaborated with many artists, including Bonnard, Vuillard, Roussel, Toulouse-Lautrec, and Vallotton on illustrations and covers for the review. Bonnard designed an advertising poster for *La Revue Blanche* in 1894.
Natanson also wrote several articles on Bonnard, including "Adieu à Bonnard" published in *Peints à leur tour* (1948).

Misia GODEBSKA (1872-1950).

A talented concert pianist and daughter of the sculptor Cyprien Godebski, Misia married Thadée Natanson in 1893. She was later married to Alfred Edwards (in 1905) and finally to Spanish painter José-Maria Sert. A charismatic subject or inspiration for many avant-garde painters, writers, and musicians (especially the Ballets Russes), Misia was painted several times by Bonnard.

Cipa GODEBSKI.

Misia Godebska's half-brother with whom she was very close. Cipa was an active participant in the turn-of-the-century avant-garde and was especially close to the composer Maurice Ravel, who dedicated several works to him.

Ida GODEBSKA.

Wife of Cipa Godebski.

Alfred EDWARDS.

Businessman and newspaper owner, he was Misia Godebska's second husband. Bonnard cruised on his yacht *Aimée* in 1906 (chap. 23).

Prince Emmanuel BIBESCO.

A friend of Vuillard and Marcel Proust, he traveled to Spain with Bonnard, Vuillard and his brother Antoine, in 1901 (chap. 13). He took many photographs of Bonnard and Vuillard during this voyage.

Madame SCHOPFER.

Wife of Jean Schopfer, who was more well-known under his pseudonym Claude Anet. Anet wrote an article about Bonnard published in *Le Gil Blas* (1910). Madame Schopfer and her husband collected paintings by contemporary artists (including Bonnard, Vuillard, and Maurice Denis), and commissioned three large panels from Vuillard for their apartment (1898-1901). Bonnard illustrated Schopfer's *Notes sur l'amour* in 1922.

Madame REDON.

Wife of Odilon Redon, an artist whom Bonnard greatly admired.

Bonnard's dog Black
Bonnard's dog Ubu
Trotty, Charles Terrasse's donkey
A goat
Diverse unidentified persons
Domestic help and nursemaids
A striped cat
A two-toned cat
The Family dog
A goat

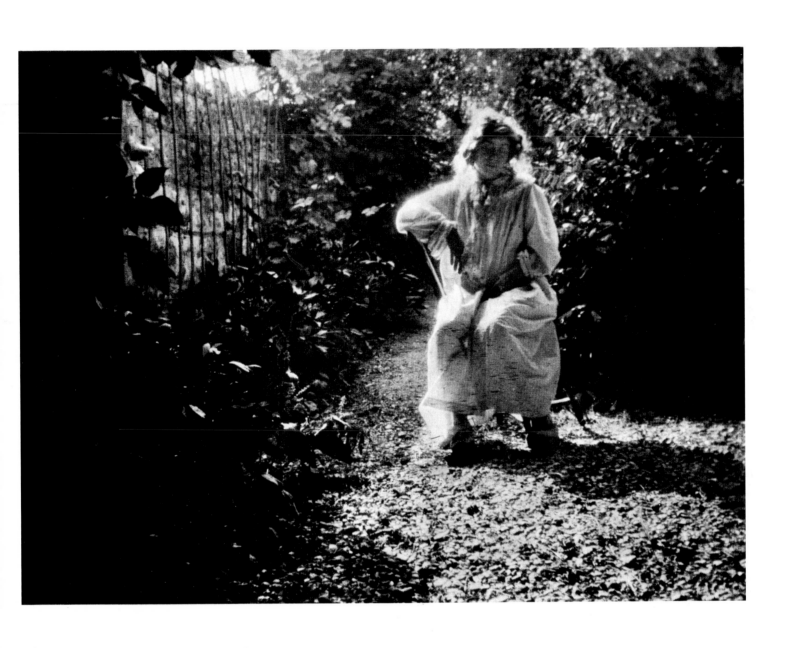

Planche 1 (n° 118) 1900-1901
Marthe

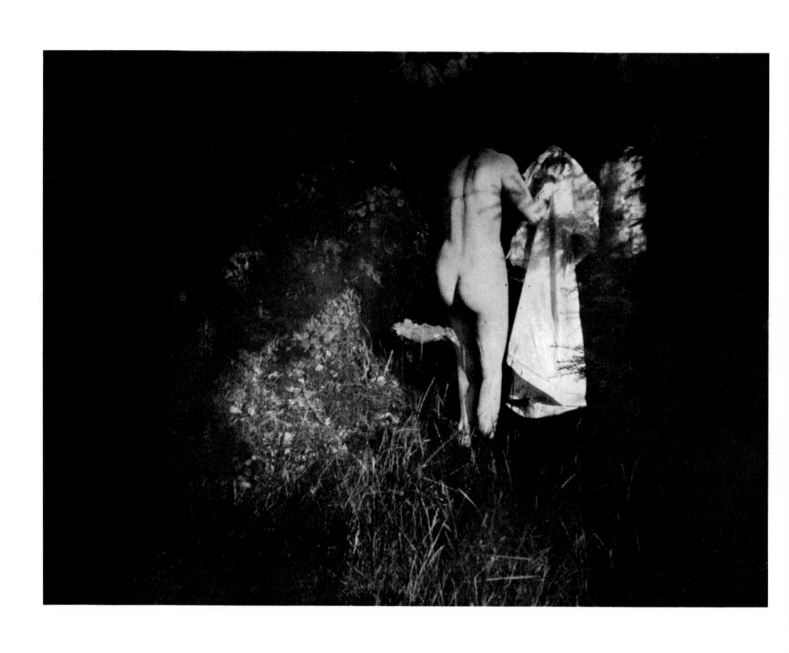

Planche 2 (nᵒ 122) 1900-1901
Marthe

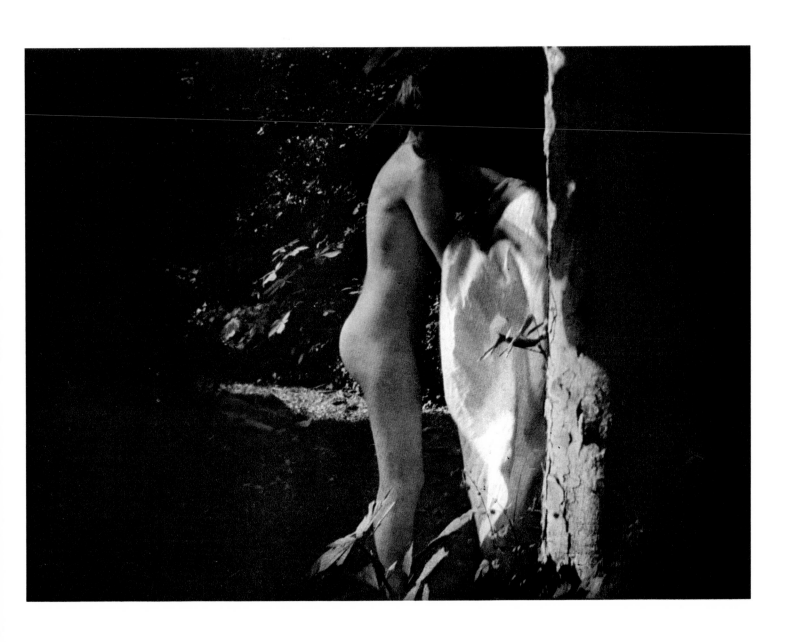

Planche 3 (nº 120) 1900-1901
Marthe

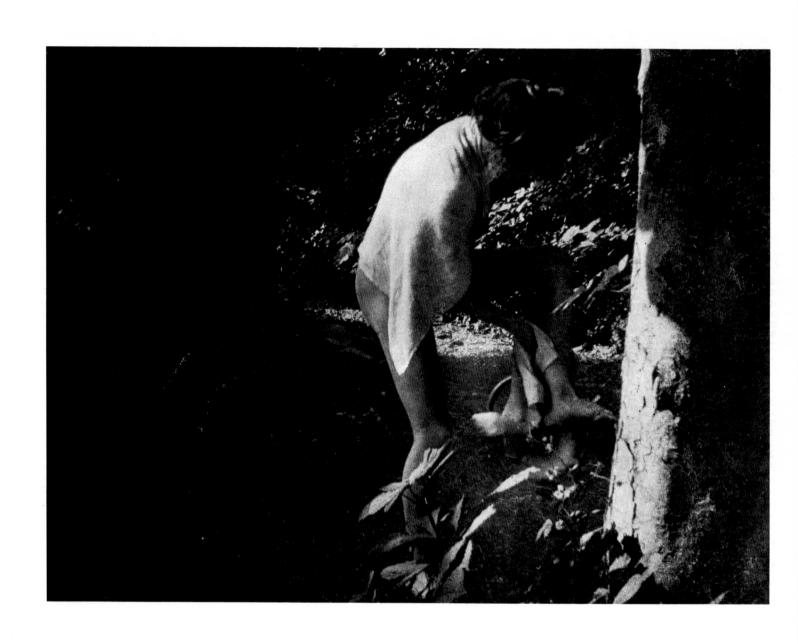

Planche 4 (n° 128) 1900-1901
Marthe

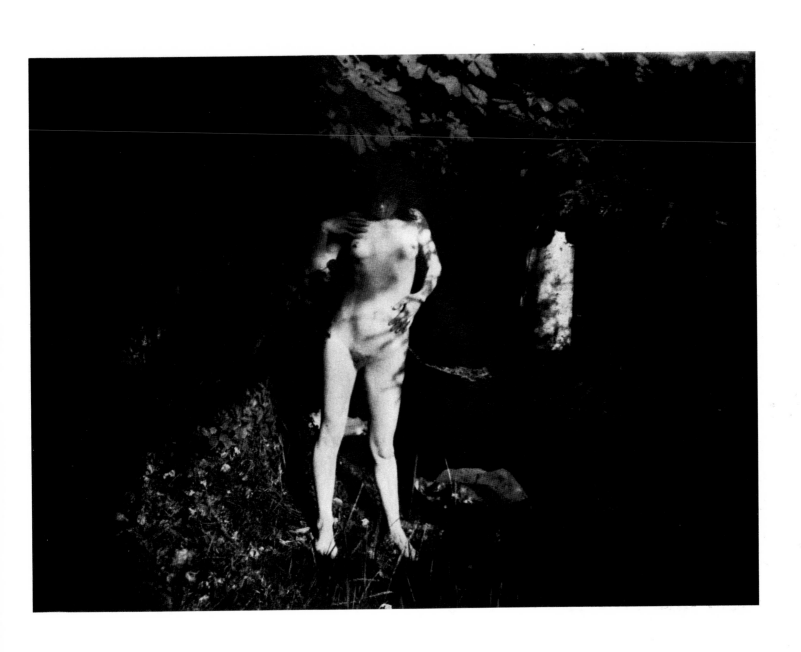

Planche 5 (n° 129) 1900-1901
Marthe

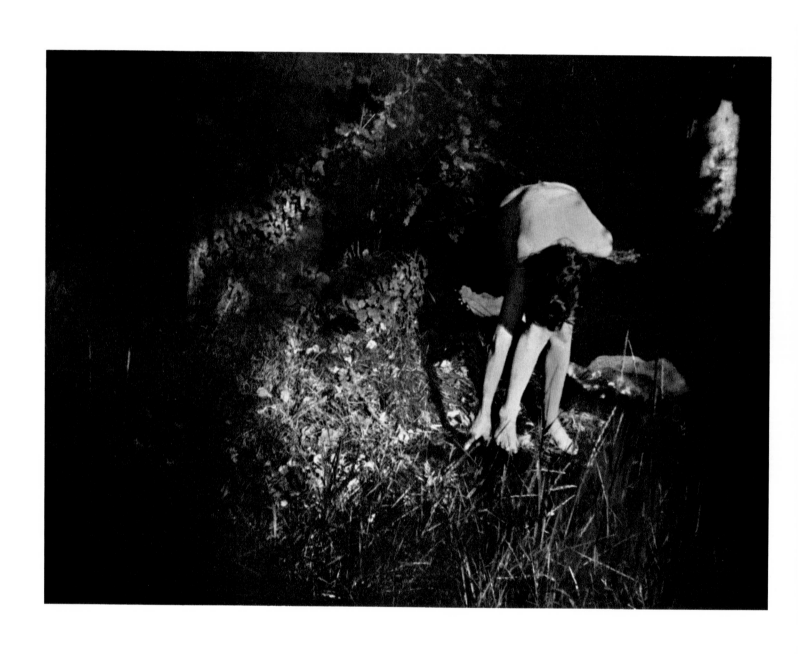

Planche 6 (nº 130) 1900-1901
Marthe

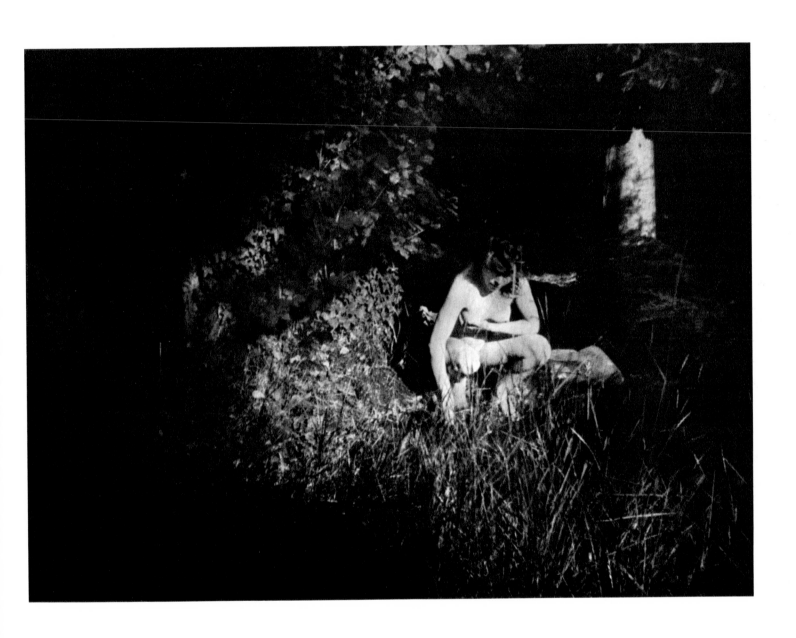

Planche 7 (n° 131) 1900-1901
Marthe

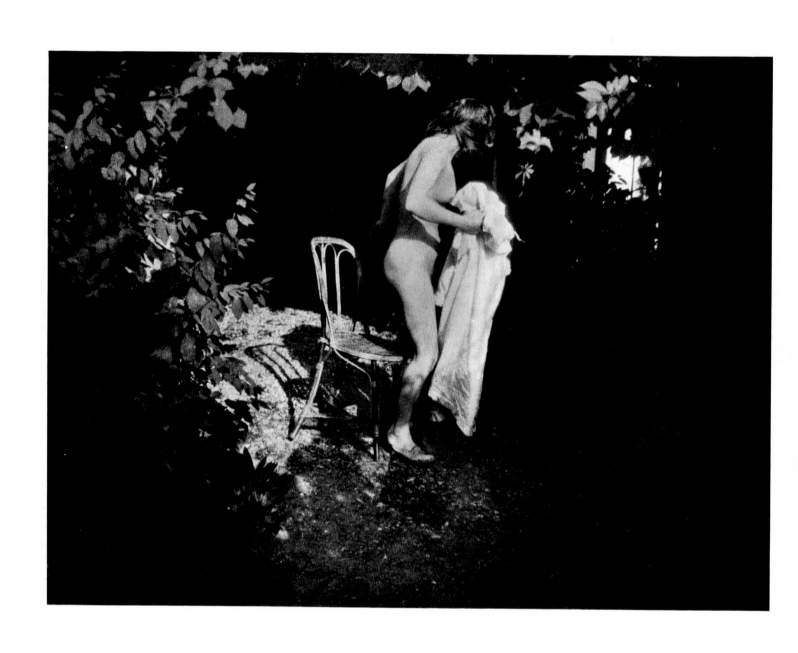

Planche 8 (n° 133) 1900-1901
Marthe

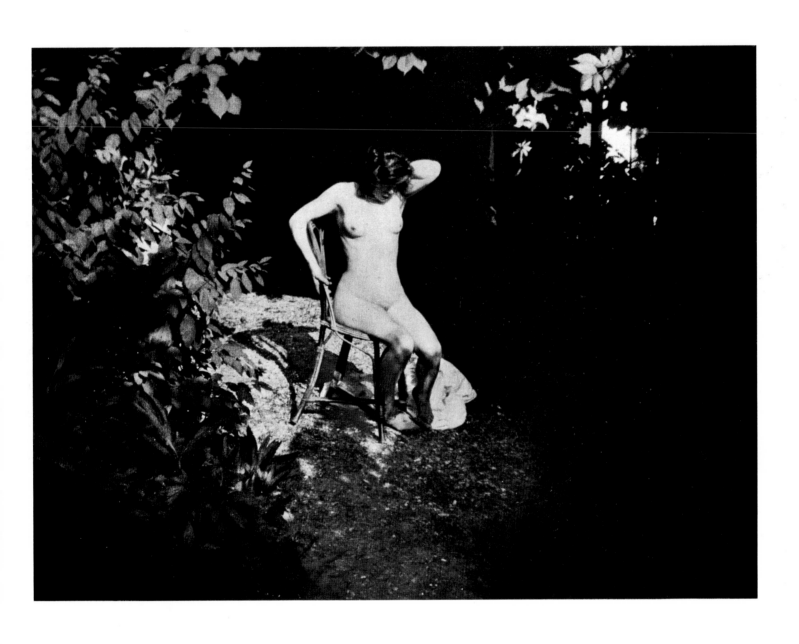

Planche 9 (n° 134) 1900-1901
Marthe

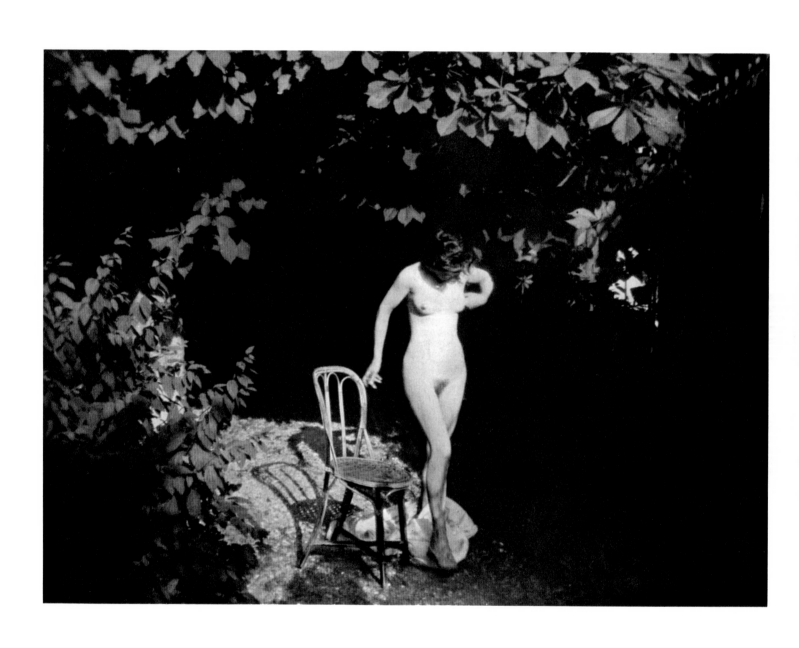

Planche 10 (n° 132) 1900-1901
Marthe

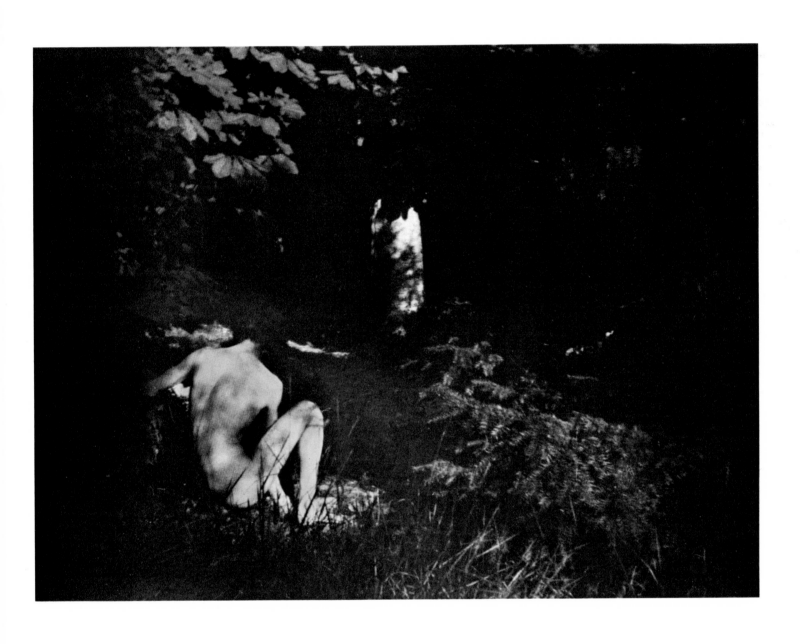

Planche 15 (n° 139) 1900-1901
Pierre Bonnard (prise de vue de Marthe)
Pierre Bonnard (photograph taken by Marthe)
Pierre Bonnard (Aufgenommen von Marthe)

31

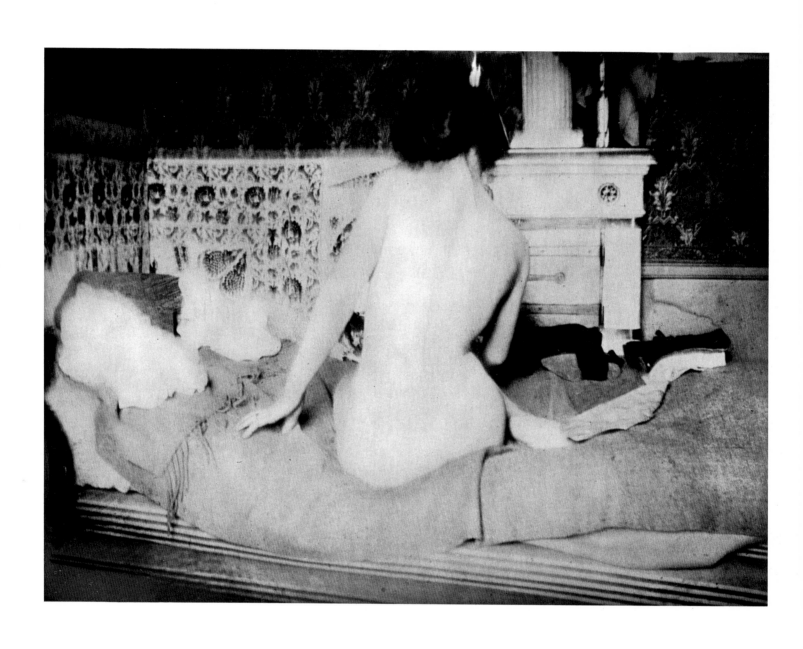

Planche 16 (n° 112) 1899-1900
Marthe

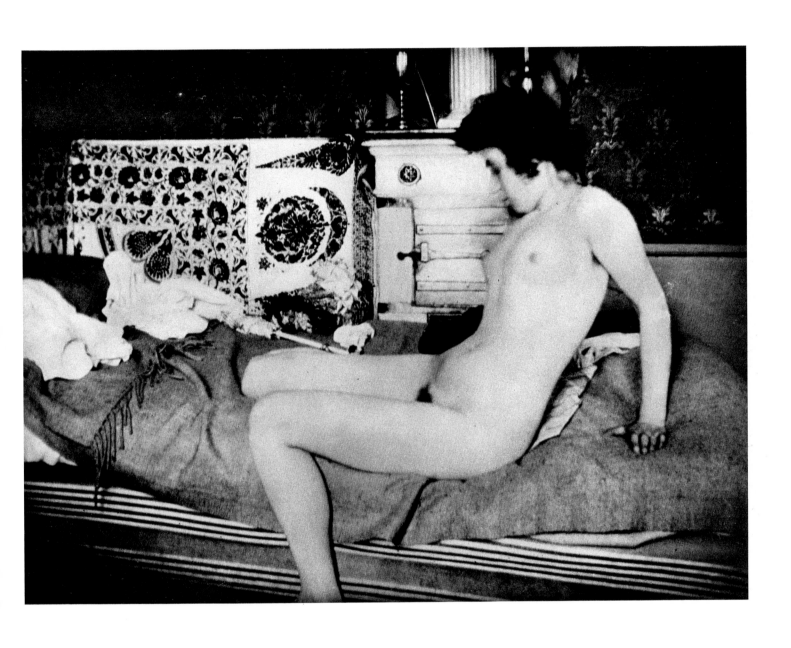

Planche 17 (n° 108) 1899-1900
Marthe

33

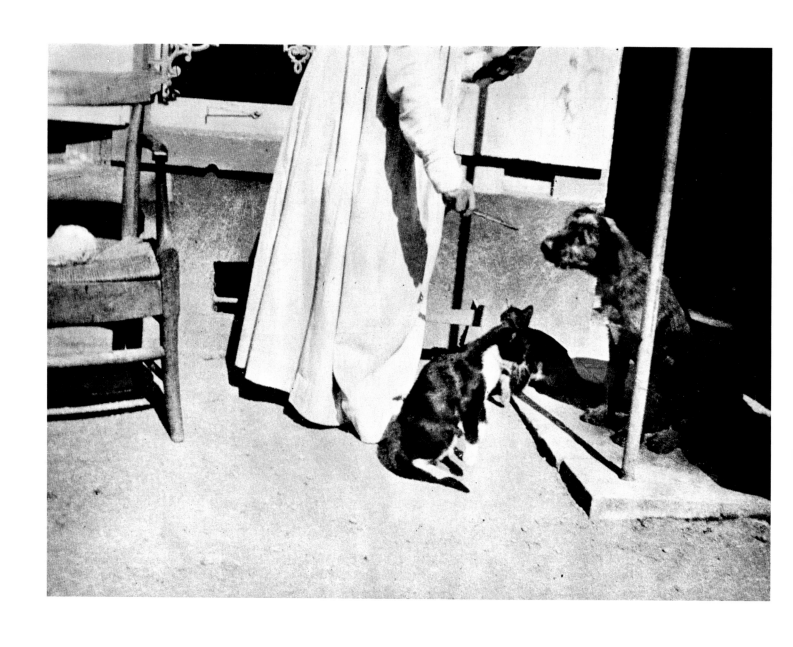

Planche 18 (n° 3) 1898
Andrée Terrasse jouant avec des animaux
Andrée Terrasse playing with the family pets
Andrée Terrasse, mit den Haustieren spielend

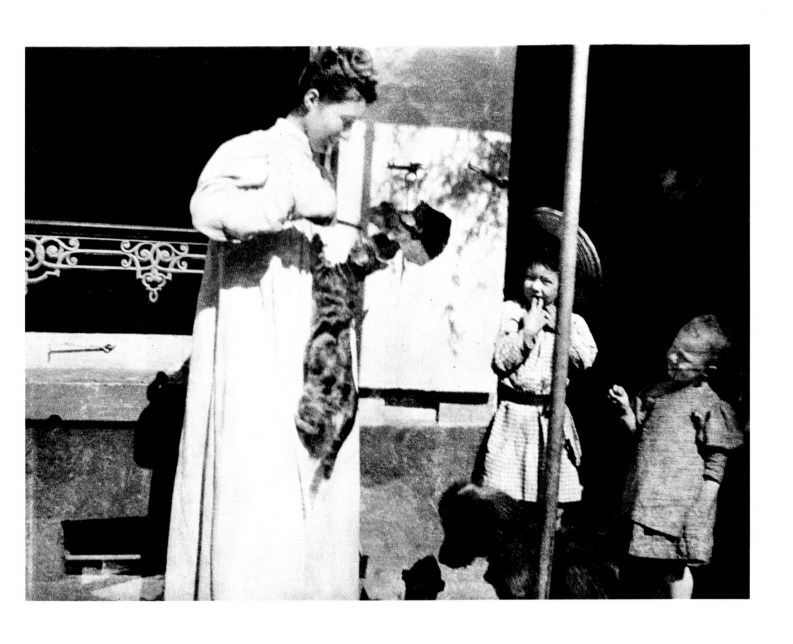

Planche 19 (n° 4) 1898
Un chat sautant sur la robe d'Andrée Terrasse
A cat leaping up at Andrée Terrasse.
Katze, an Andrée Terrasse hochspringend

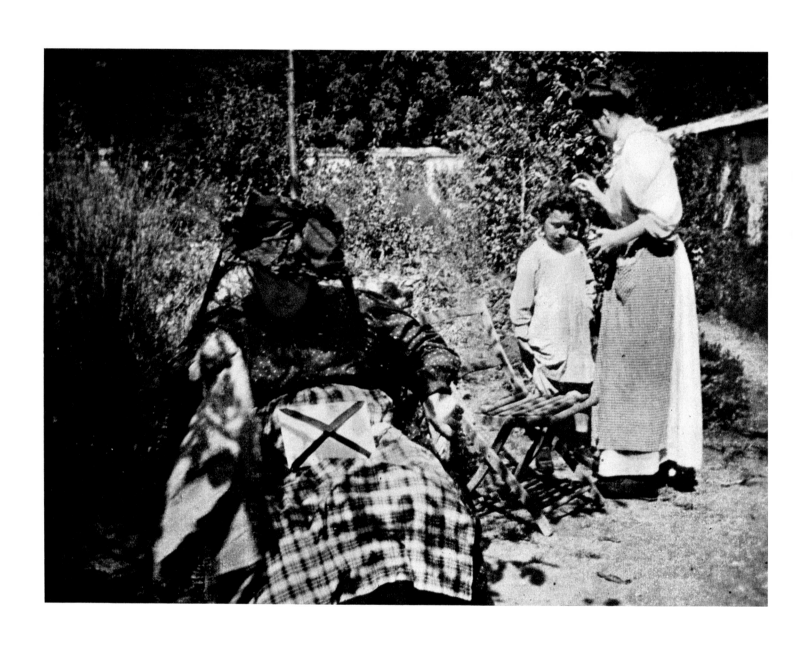

Planche 20 (nᵒ 7) 1898
Mme Mertzdorff, Andrée et Jean Terrasse

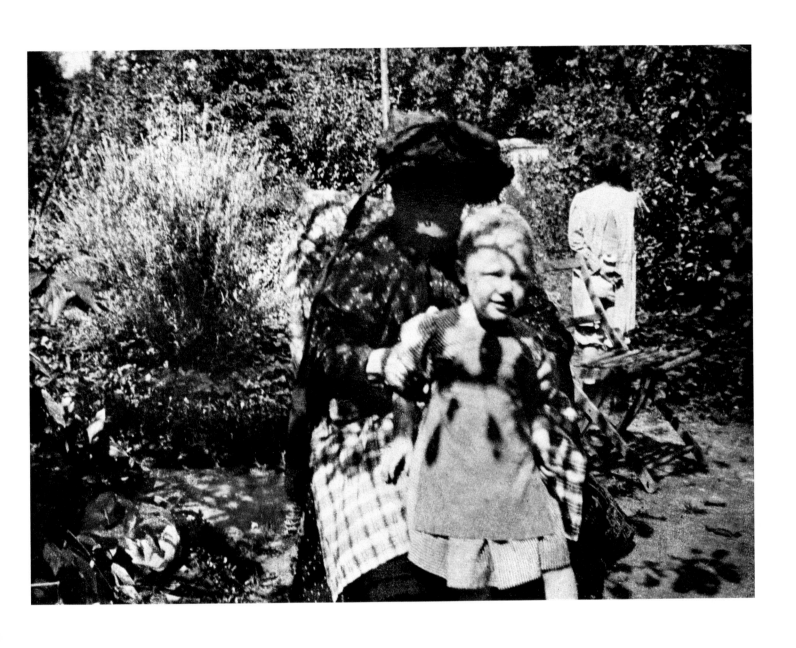

Planche 21 (n° 8) 1898
Mme Mertzdorff, Robert et Charles

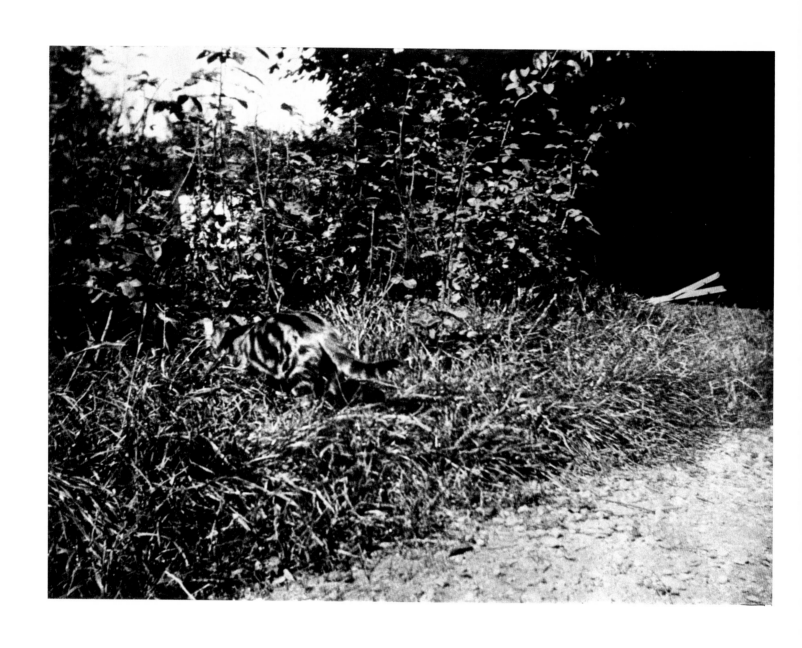

Planche 22 (n° 5) 1898
Un chat sautant dans les fourrés
A cat diving into the undergrowth
Katze im Dickicht

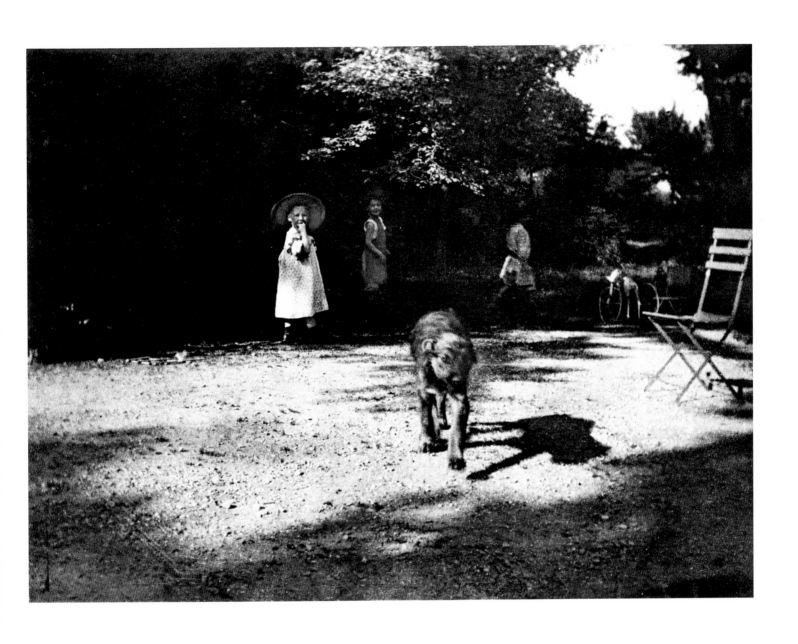

Planche 23 (n° 23) 1898
Le chien de la famille
The family dog
Der Hund der Familie

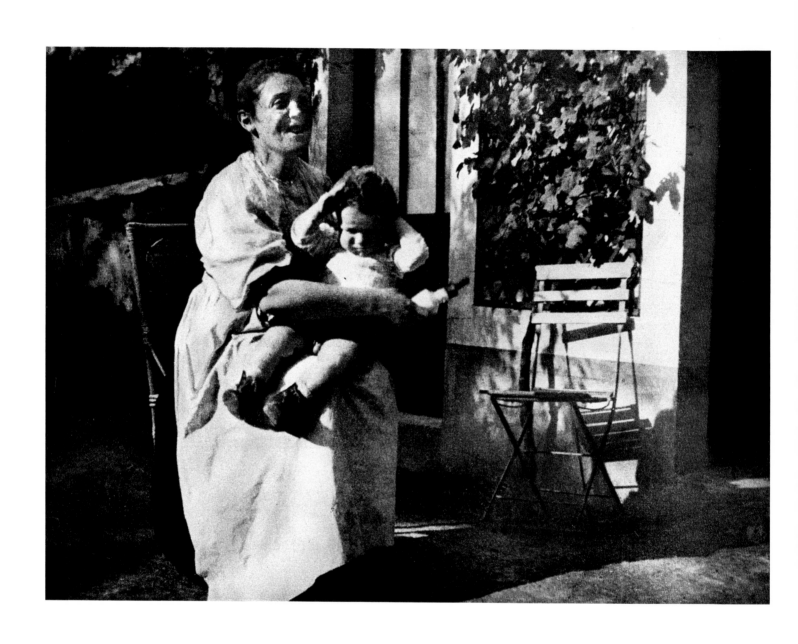

Planche 24 (n° 13) 1898
Marcel et sa nourrice
Marcel and his nursemaid
Marcel und sein Kindermädchen

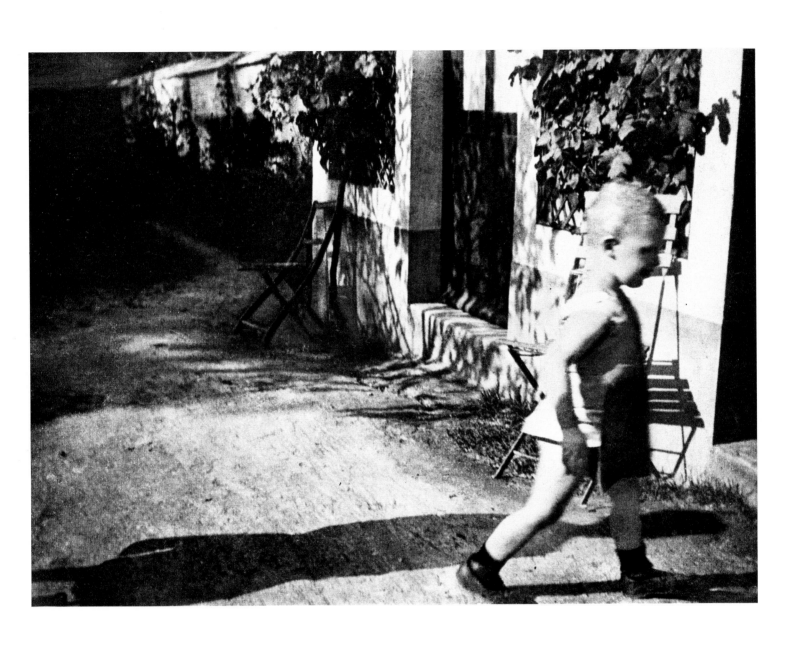

Planche 25 (n° 18) 1898
Robert

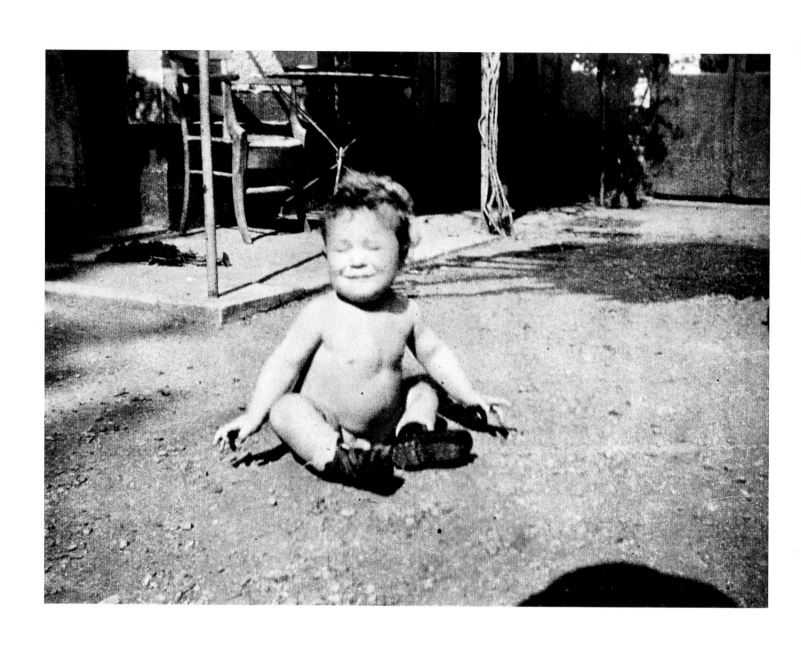

Planche 26 (nº 14) 1898
Marcel

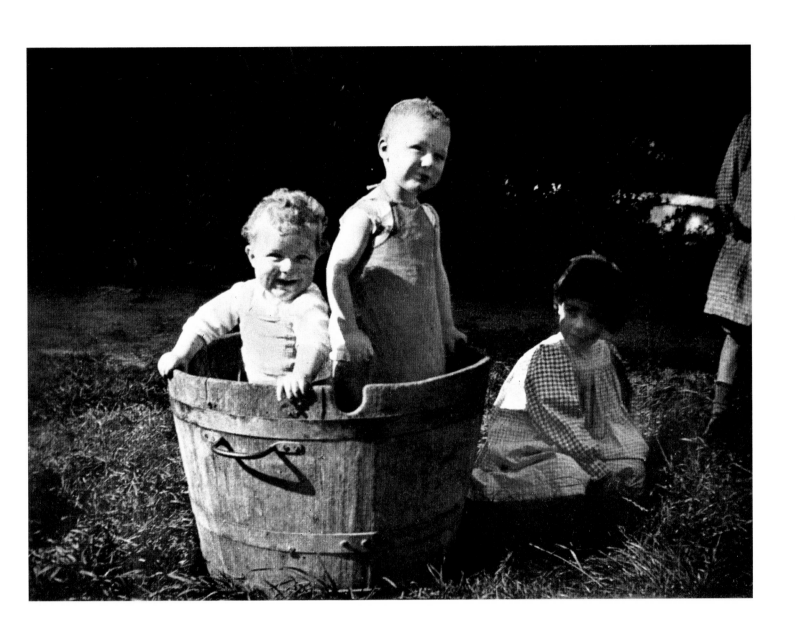

Planche 27 (n° 20) 1898
Marcel, Robert et Renée

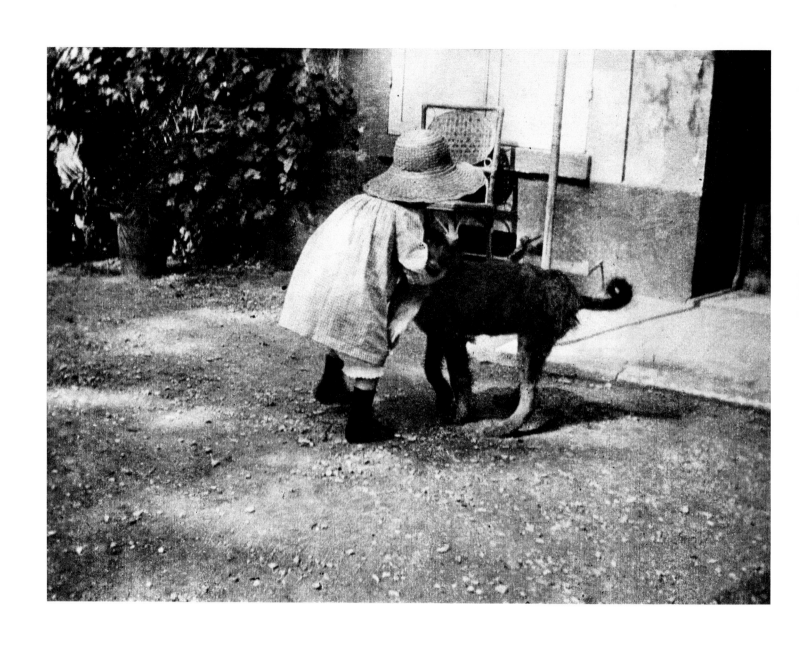

Planche 28 (nº 6) 1898
Renée embrassant un chien
Renée hugging a dog
Renée den Hund umarmend

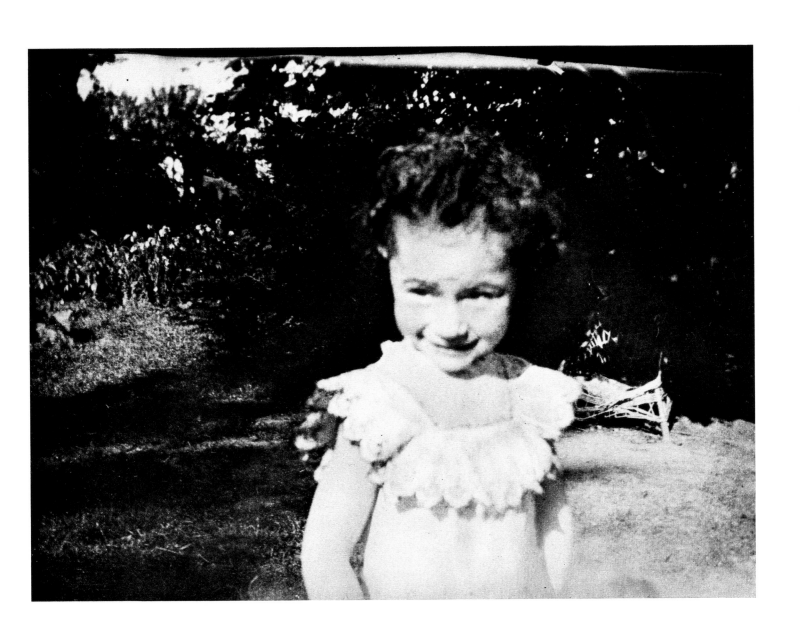

Planche 29 (nº 36) 1899
Renée

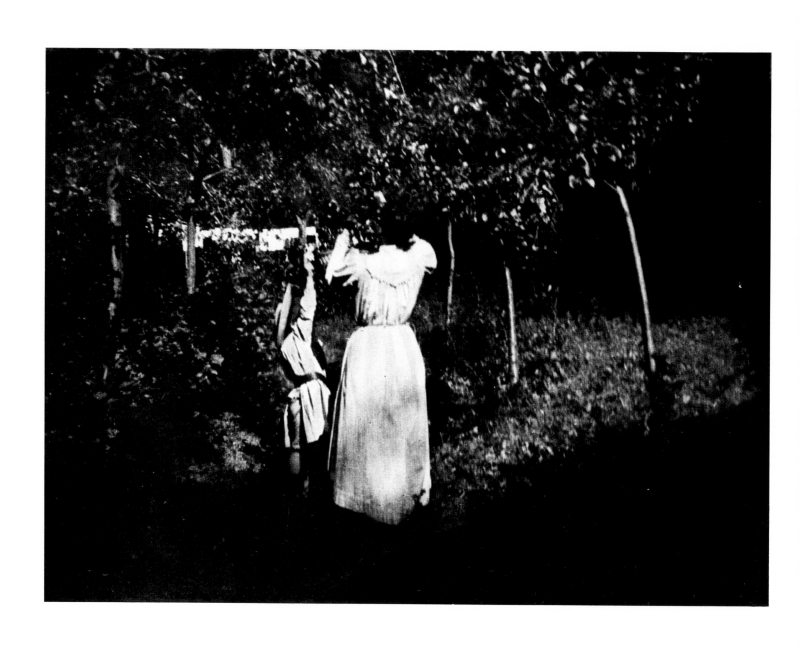

Planche 30 (n° 81) 1899-1900
La cueillette
Picking fruit
Beim Obstpflücken

46

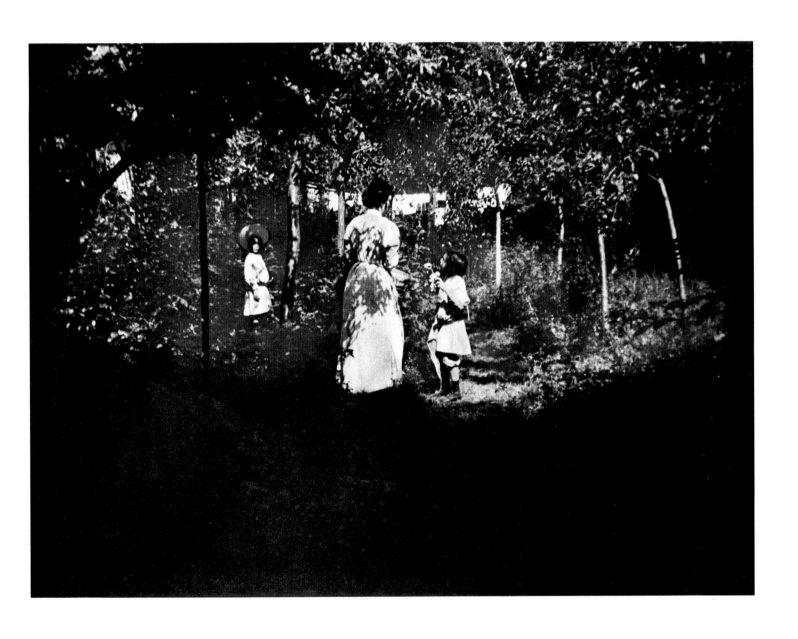

Planche 31 (nº 80) 1899-1900
La cueillette
Picking fruit
Beim Obstpflücken

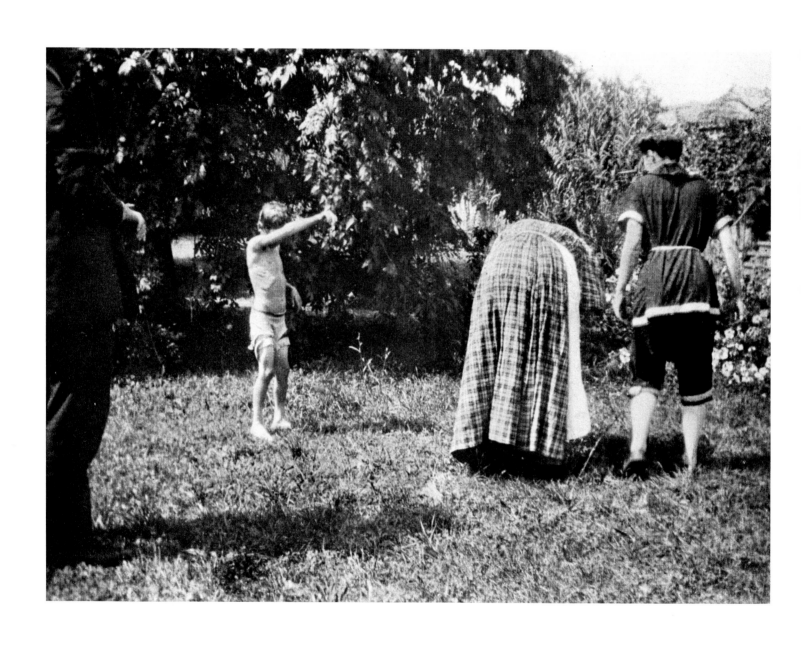

Planche 32 (nº 49) 1899
Claude, Andrée et Charles Terrasse avec une nourrice
Claude, Andrée and Charles Terrasse with a nursemaid
Claude, Andrée und Charles Terrasse mit dem Kindermädchen

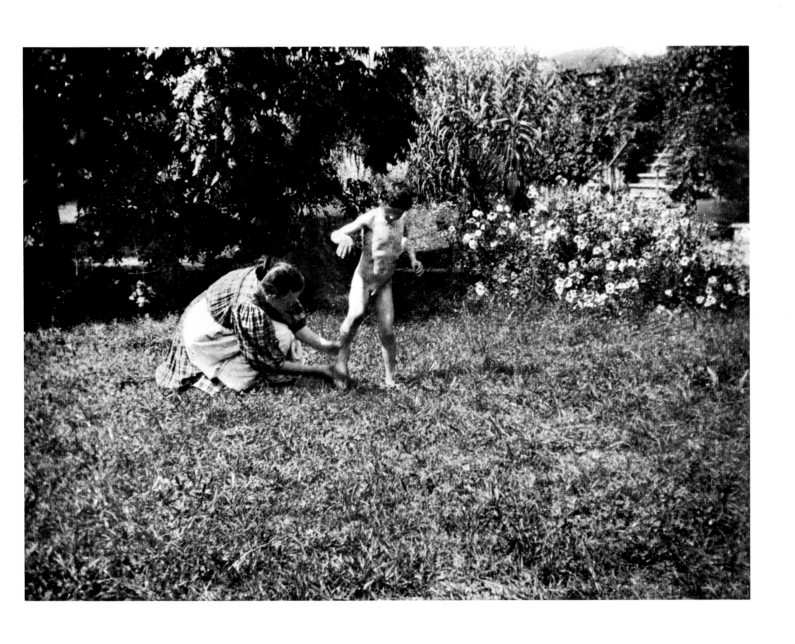

Planche 33 (n° 56) 1899
Charles et une nourrice
Charles and a nursemaid
Charles und ein Kindermädchen

49

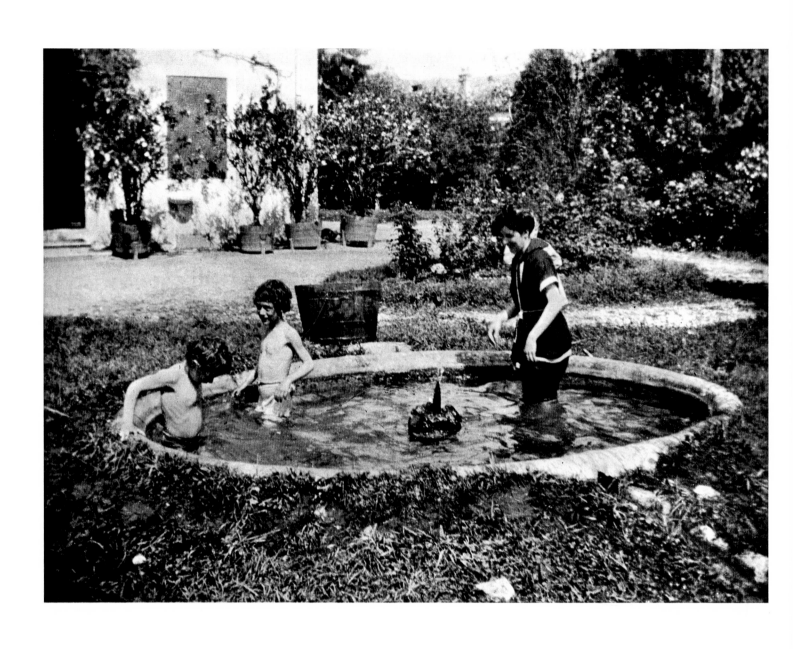

Planche 34 (n° 45) 1899
Andrée, Charles et Jean Terrasse

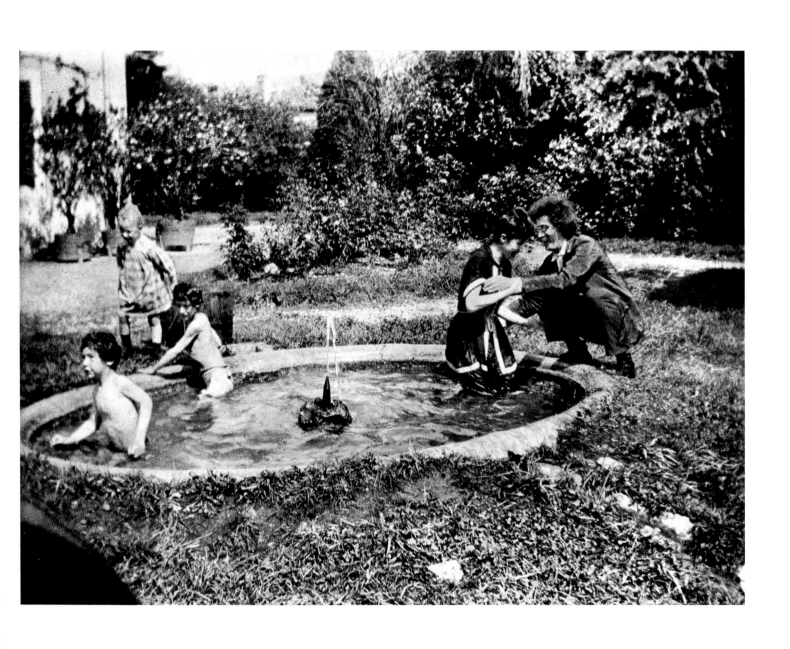

Planche 35 (nᵒ 46) 1899
Claude, Andrée, Charles et Jean Terrasse

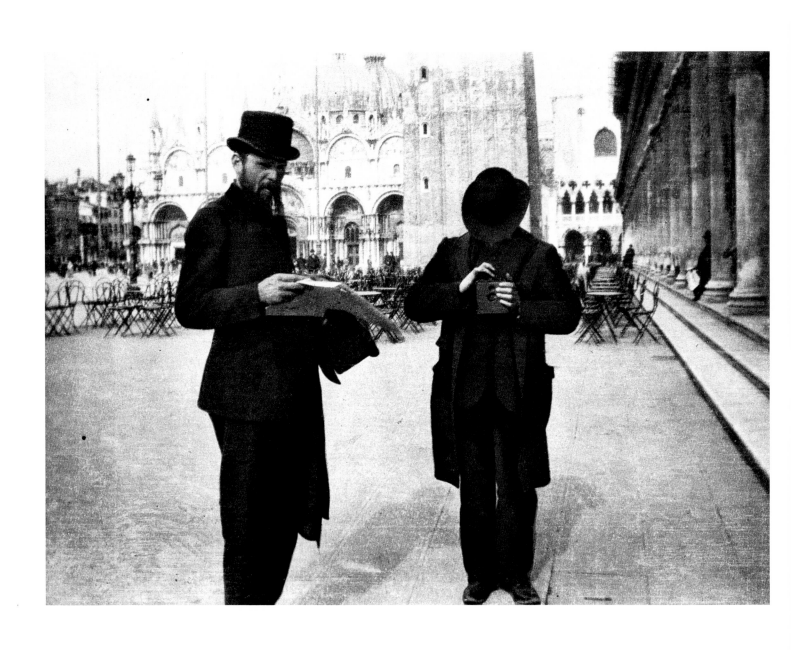

Planche 36 (n° 72) 1899
Ker-Xavier Roussel et Edouard Vuillard
Venise / Venice / Venedig

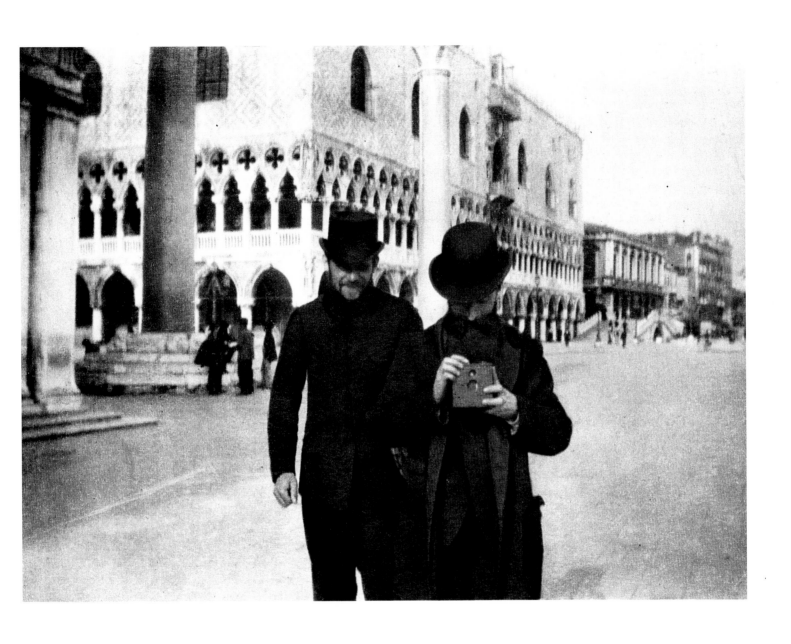

Planche 37 (n° 73) 1899
Ker-Xavier Roussel et Edouard Vuillard
Venise / Venice / Venedig

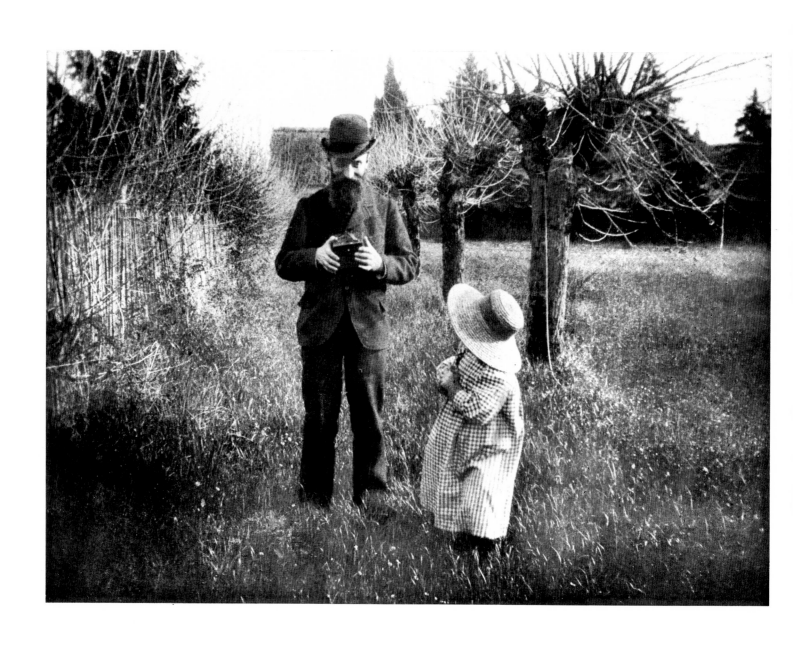

Planche 38 (n° 101) 1900
Edouard Vuillard et Renée

Planche 39 (nᵒ 104) 1900
Ker-Xavier Roussel et Renée

Planche 40 (nº 102) 1900
Renée

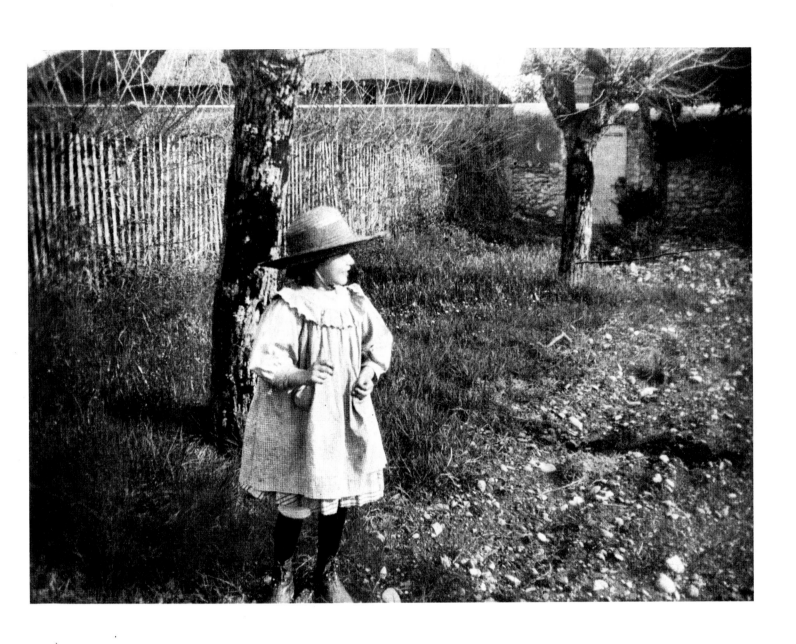

Planche 41 (n° 103) 1900
Renée

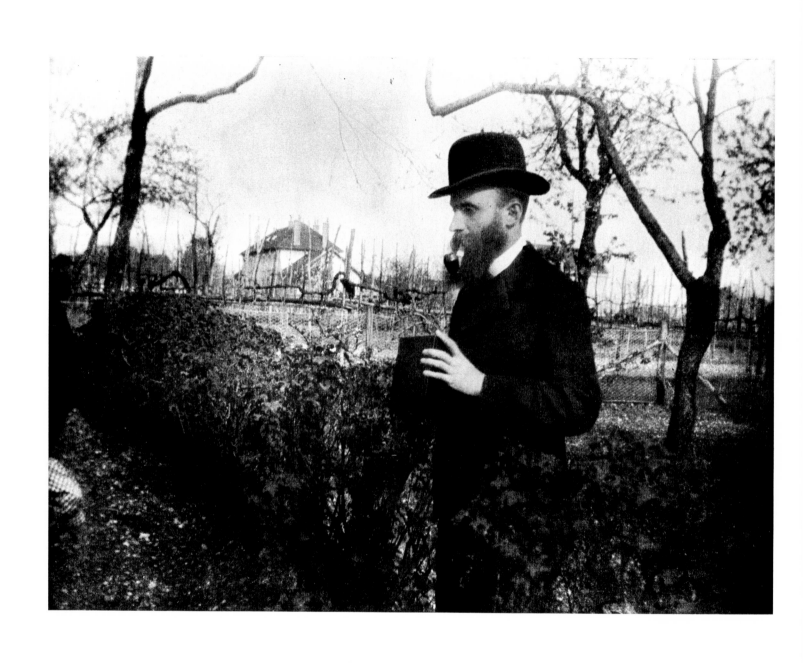

Planche 42 (nº 100) 1900
Edouard Vuillard

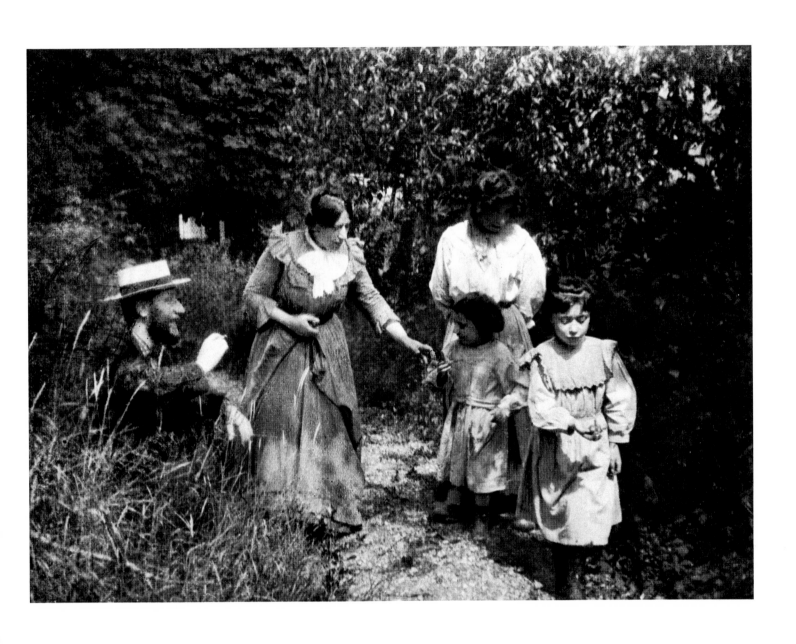

Planche 47 (n° 149) circa 1902
Charles et Eugénie Bonnard, Marthe et deux petites filles
Charles and Eugénie Bonnard, Marthe and two little girls
Charles und Eugénie Bonnard, mit Marthe und zwei kleinen Mädchen

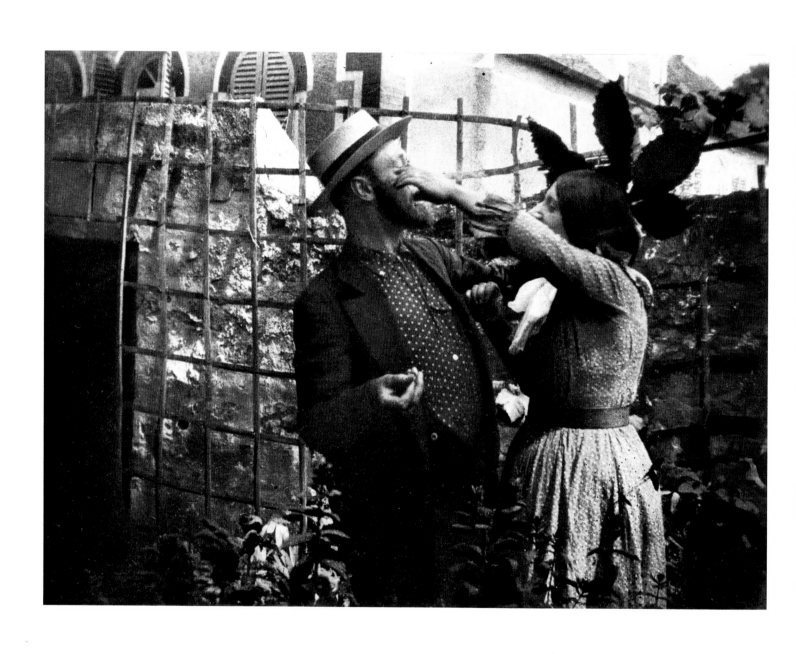

Planche 48 (n° 152) circa 1902
Charles et Eugénie Bonnard

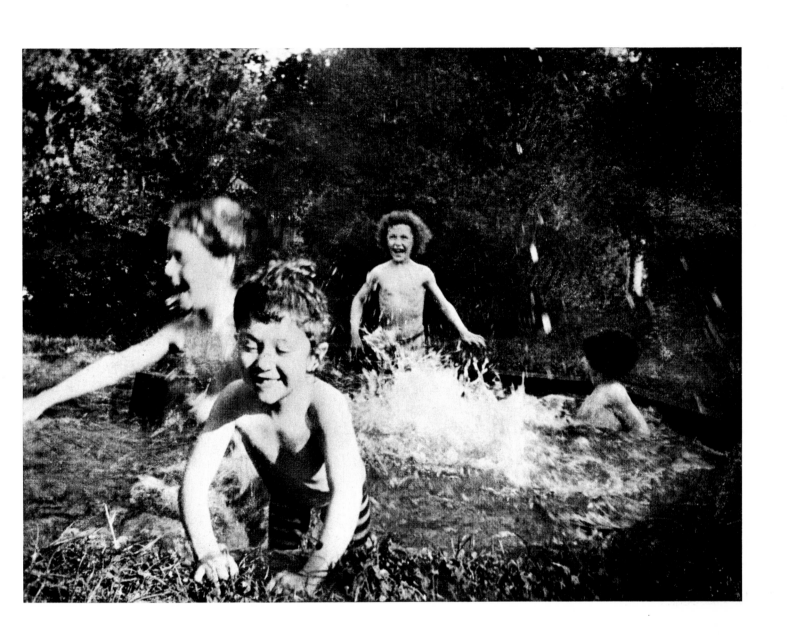

Planche 53 (n° 187) circa 1903
La baignade
Bathing
Beim Baden

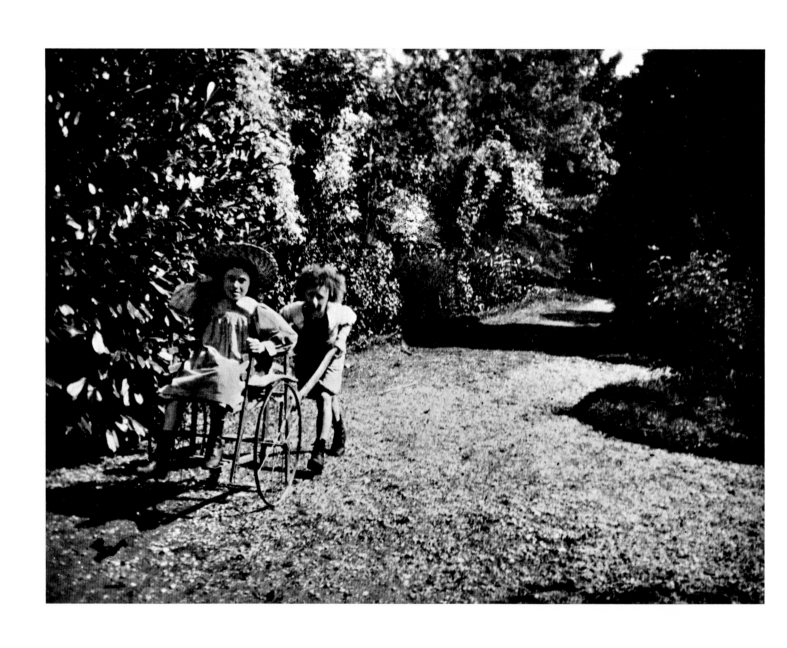

Planche 54 (n° 189) 1903-1904
Robert et Renée

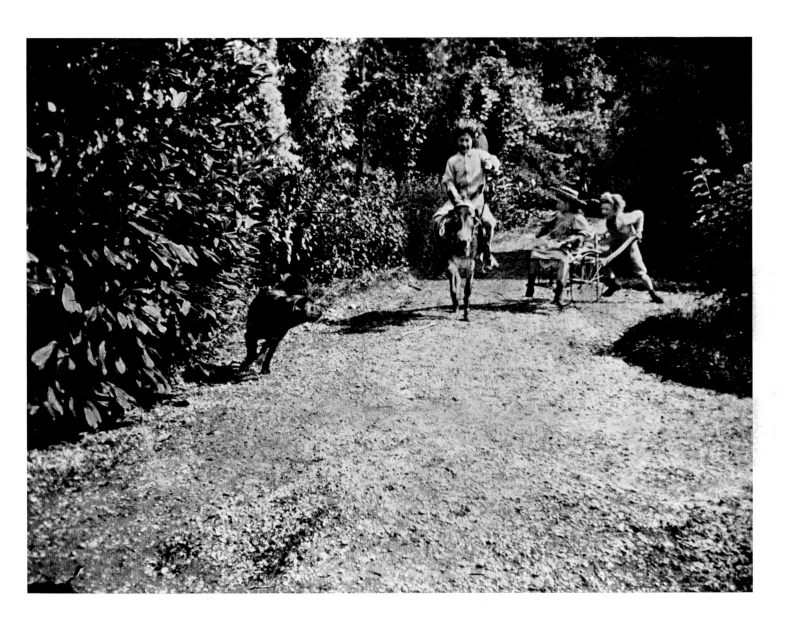

Planche 55 (n° 188) 1903-1904
Jean à dos d'âne, Robert, Renée et un chien
Jean riding a donkey with Robert, Renée and dog
Jean, auf einem Esel reitend, mit Robert, Renée und dem Hund

Page 72

Planche 56 (n° 217) circa 1912
Marthe et les Godebski en barque
Marthe and the Godebski's in a rowboat
Marthe und die Godebskis beim Rudern

Page 73

Planche 57 (n° 221) circa 1916
Le modèle au chat
Model with a cat
Modell mit Katze

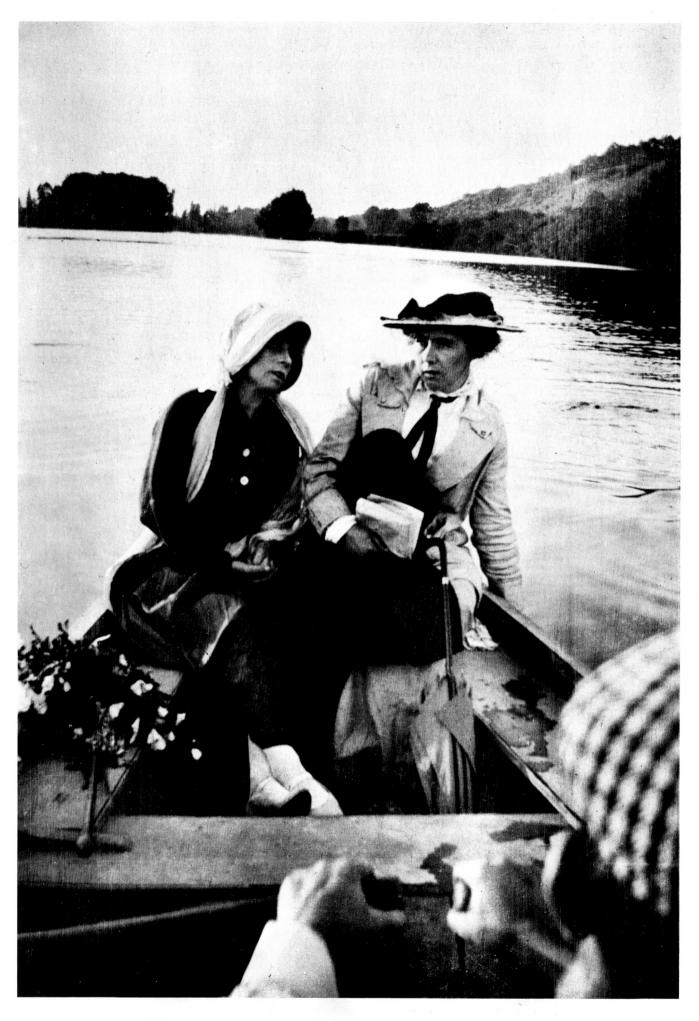

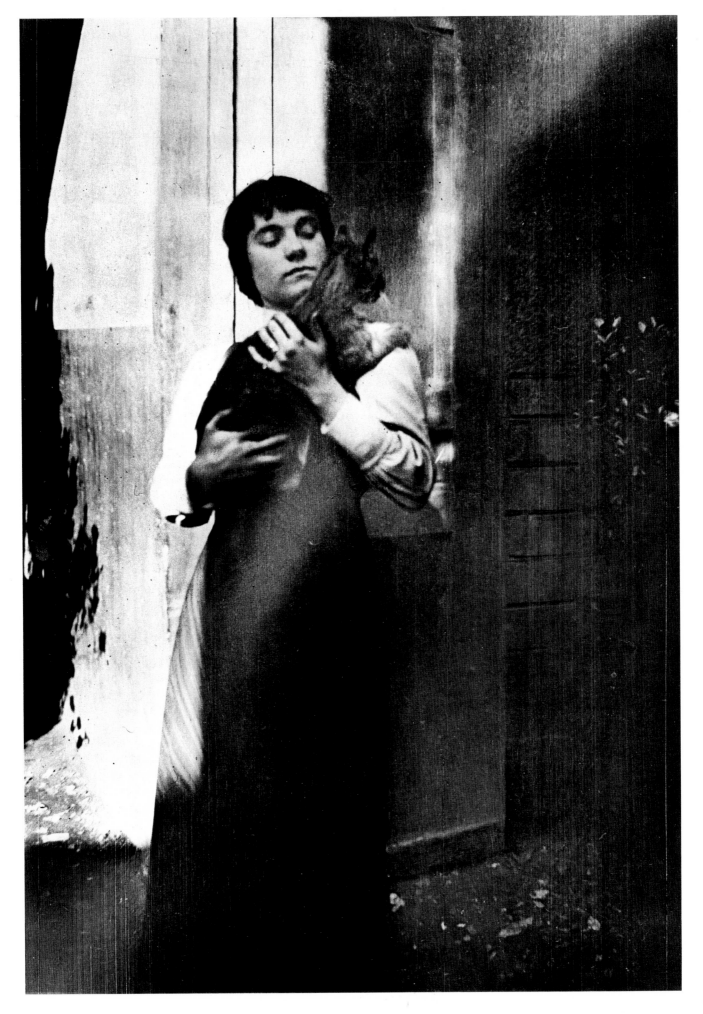

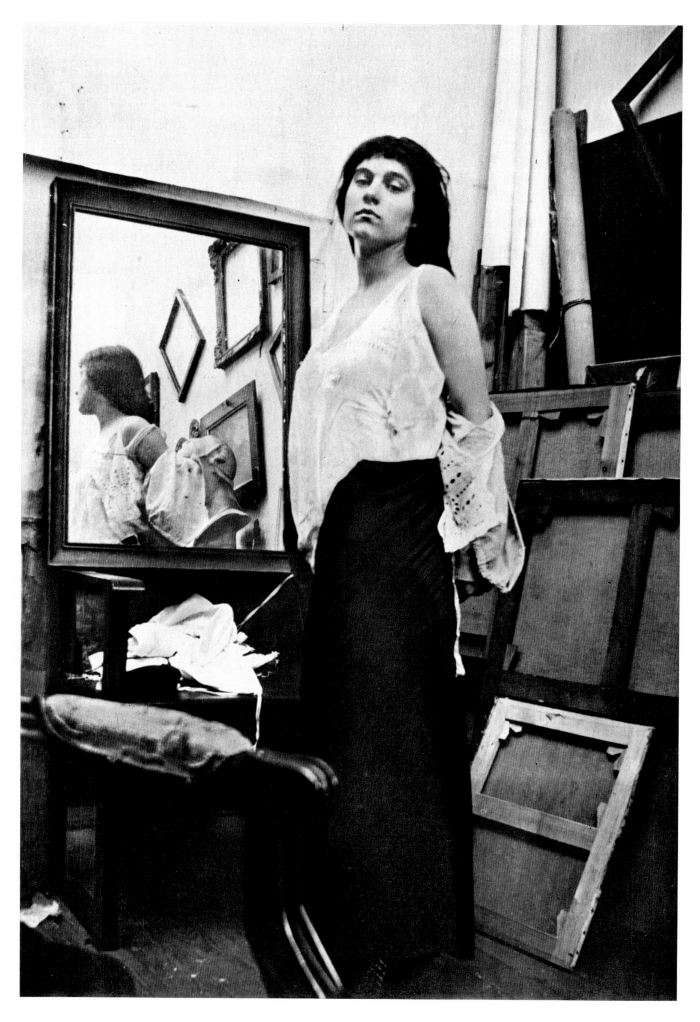

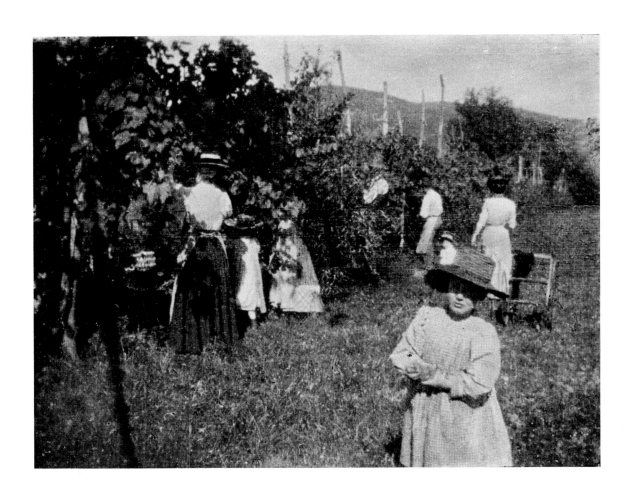

Planches 68-69 (n°ˢ 82 et 83) 1899-1900
Cueillettes de fruits
Fruit picking
Beim Obstpflücken

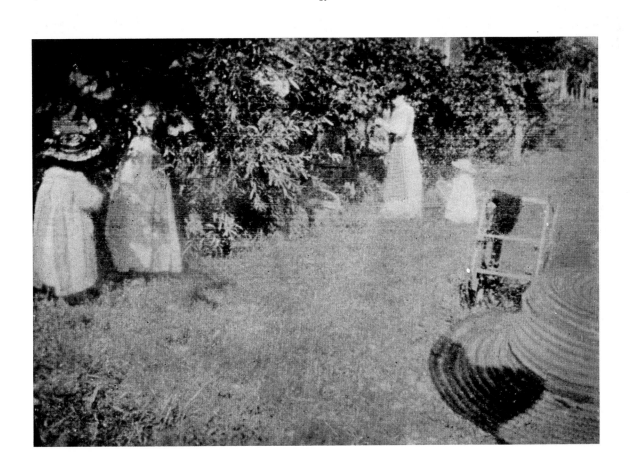

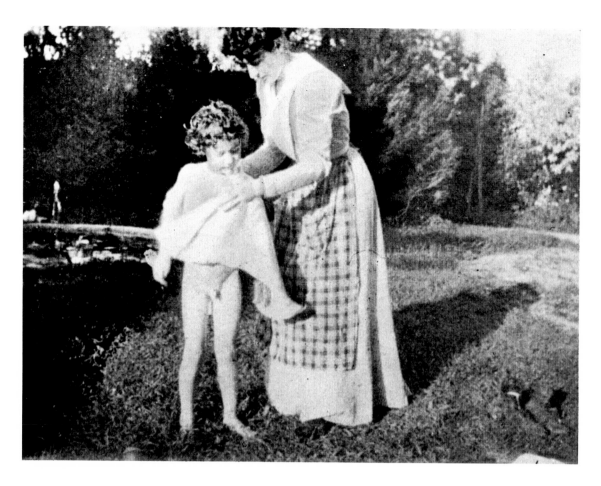

Planches 70-71 (n^{os} 57 et 58) 1899
Andrée Terrasse essuyant Charles
Andrée Terrasse drying Charles
Andrée Terrasse, Charles abtrocknend

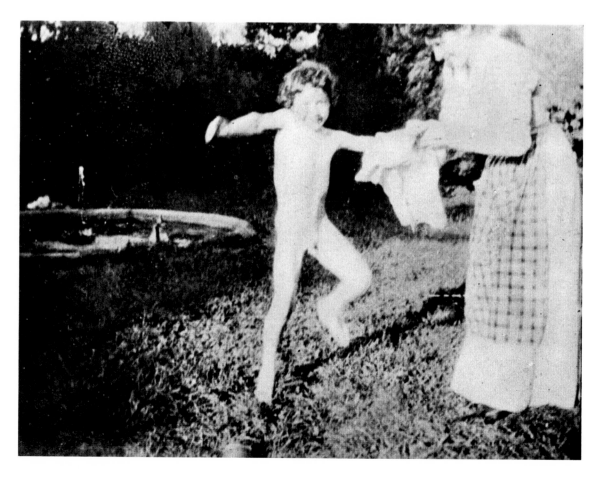

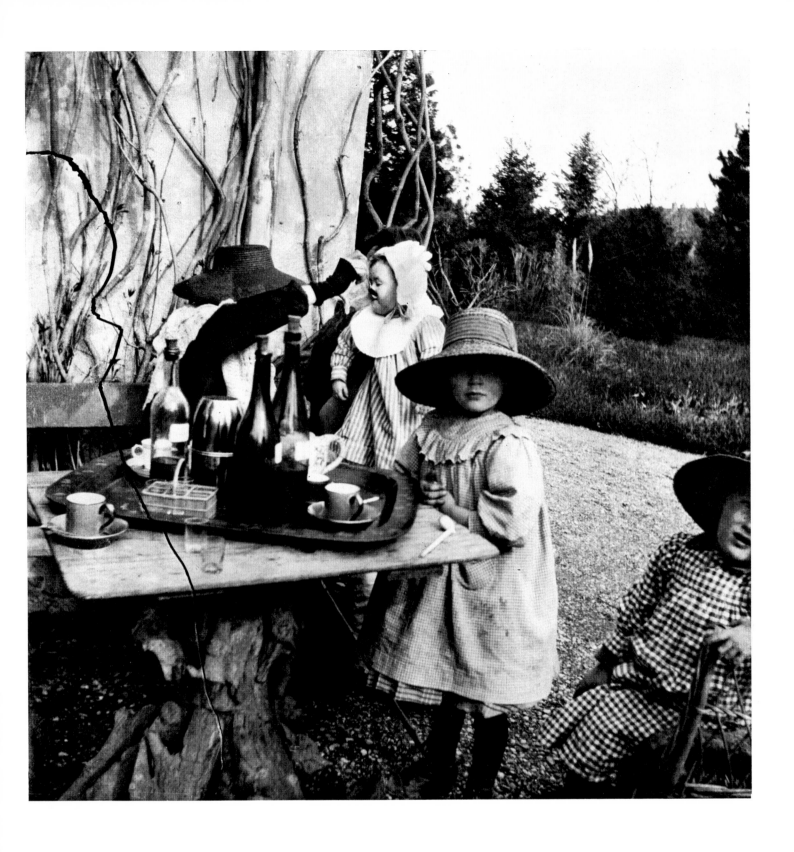

Planche 84 (Annexe D) 1900
Edouard Vuillard : Le repas de Vivette
Edouard Vuillard : Feeding Vivette
Edouard Vuillard : Vivette beim Essen

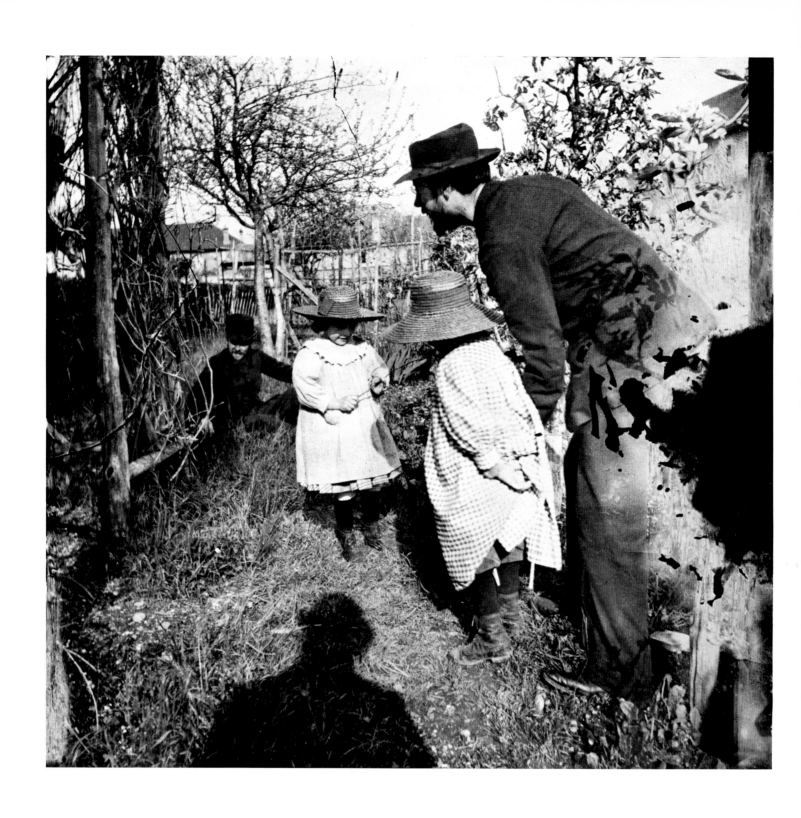

Planche 85 (Annexe B) 1900
Edouard Vuillard : Bonnard, Roussel, Renée et une petite fille
Edouard Vuillard : Bonnard, Roussel, Renée and a little girl
Edouard Vuillard : Bonnard, Roussel, Renée und ein kleines Mädchen

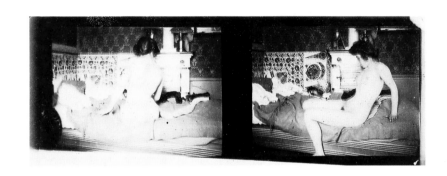

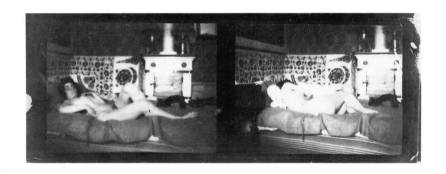

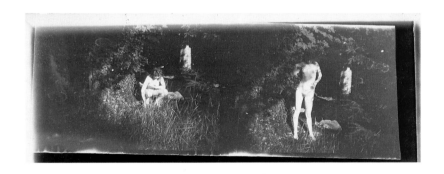

Planche I (nos 112 et 108) 1899-1900
Marthe

Planche I (nos 116 et 114) 1899-1900
Marthe

Planche I (nos 131 et 129) 1900-1901
Marthe

La bestiole céleste
S'en vient palpiter à terre,
La Folle-du-Logis reste
Dans sa gloire solitaire!

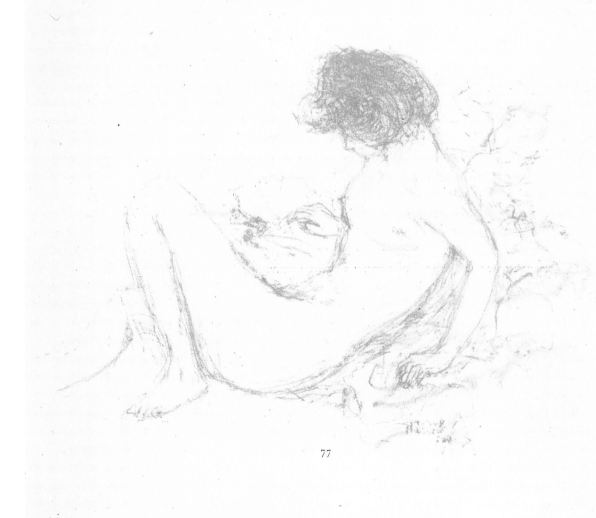

77

Planche II 1900
Illustration pour Limbes *(Parallèlement) de Verlaine*

94

« Elle a, ta chair, le charme sombre
Des maturités estivales,
Elle en a l'ambre, elle en a l'ombre;

« Ta voix tonne dans les rafales,
Et ta chevelure sanglante
Fuit brusquement dans la nuit lente.»

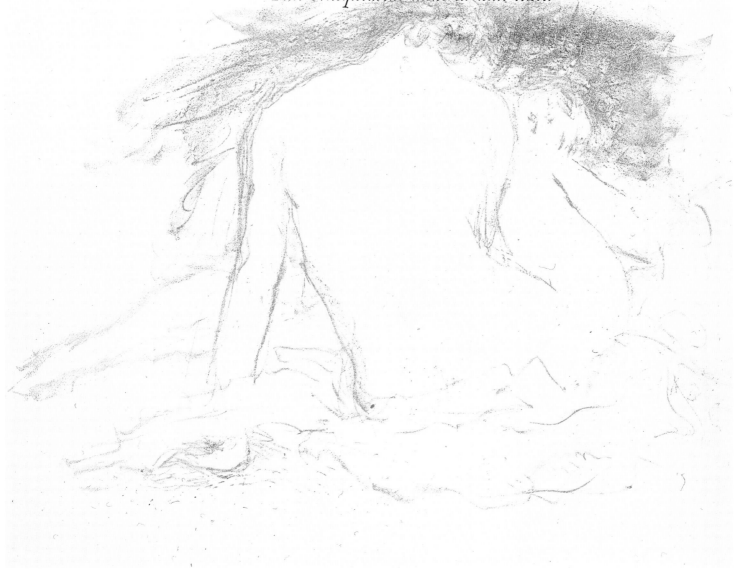

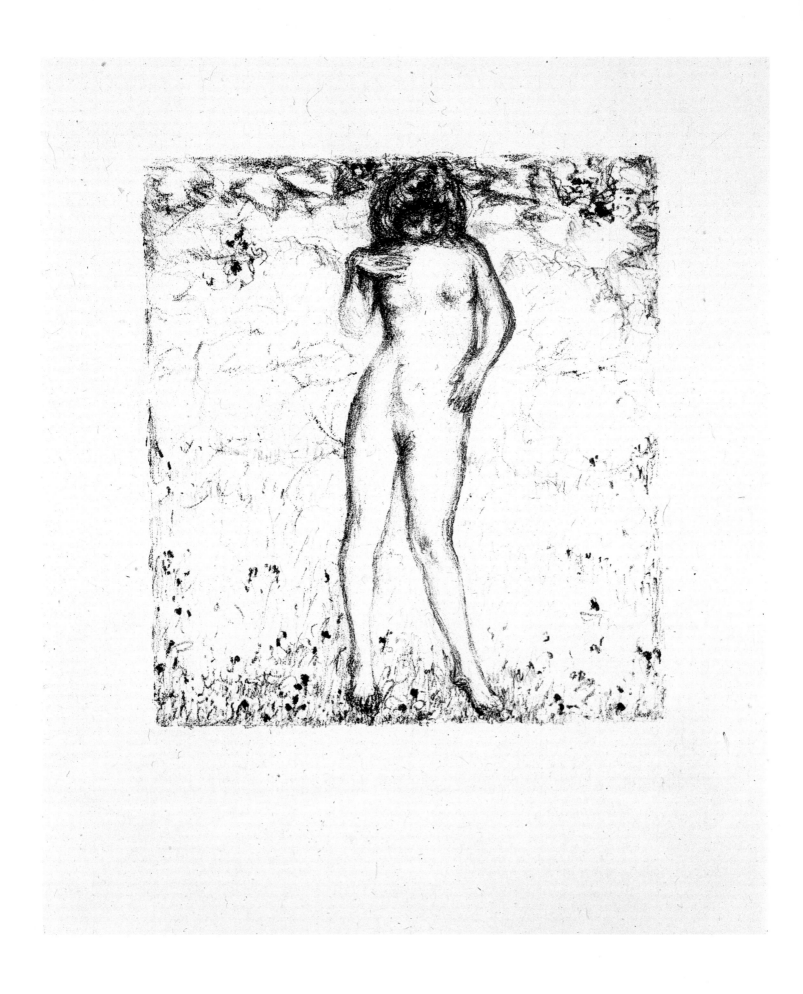

Planche IV 1902
Daphnis et Chloé

Planche V *1902*
Daphnis et Chloé

RENÉ BOYLESVE

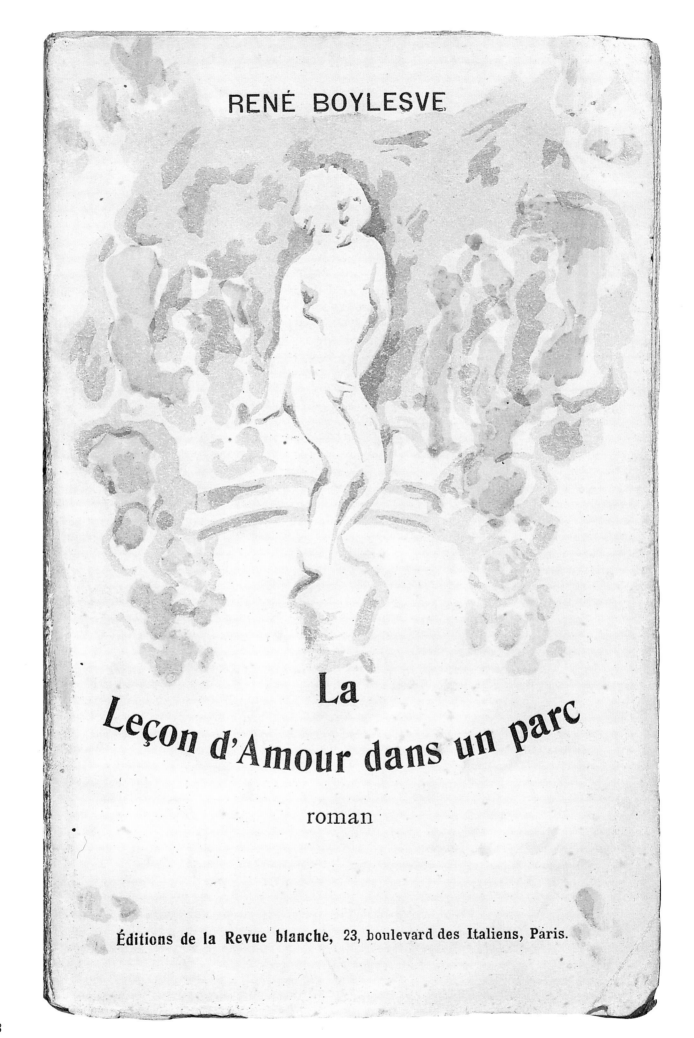

La
Leçon d'Amour dans un parc

roman

Éditions de la Revue blanche, 23, boulevard des Italiens, Paris.

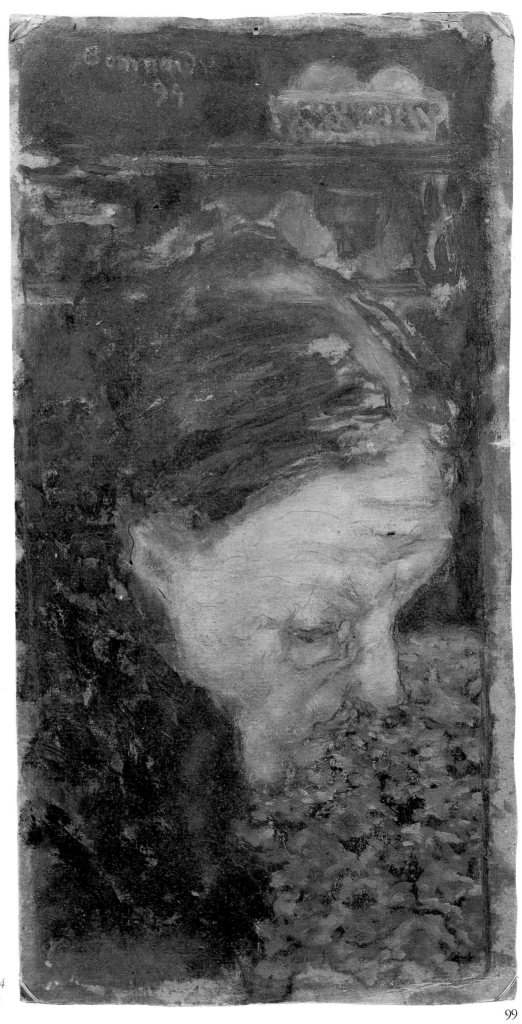

Planche VI 1902
La leçon d'amour dans un parc

Planche VII 1894
La Grand-mère

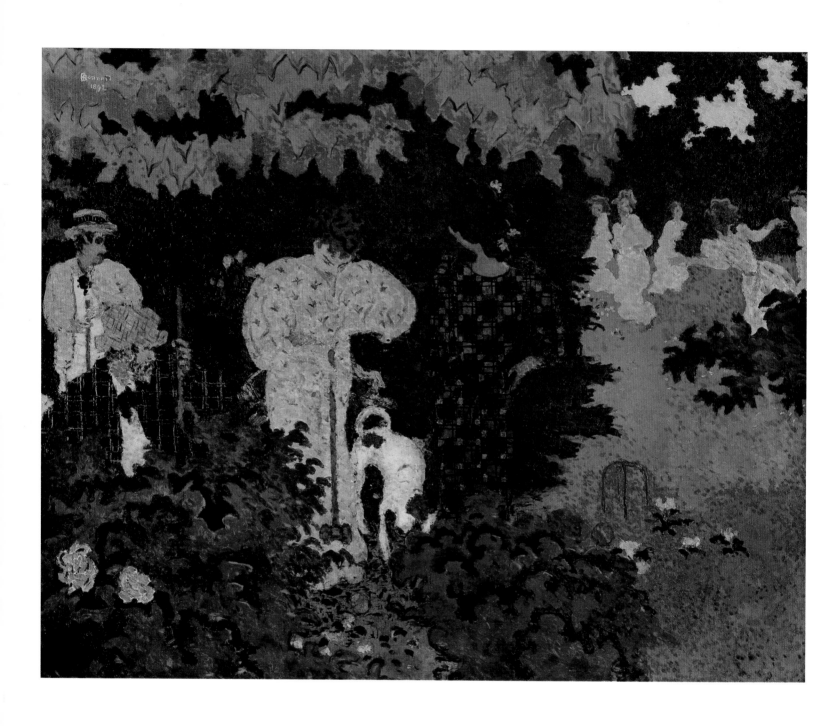

Planche VIII 1892
La Partie de croquet

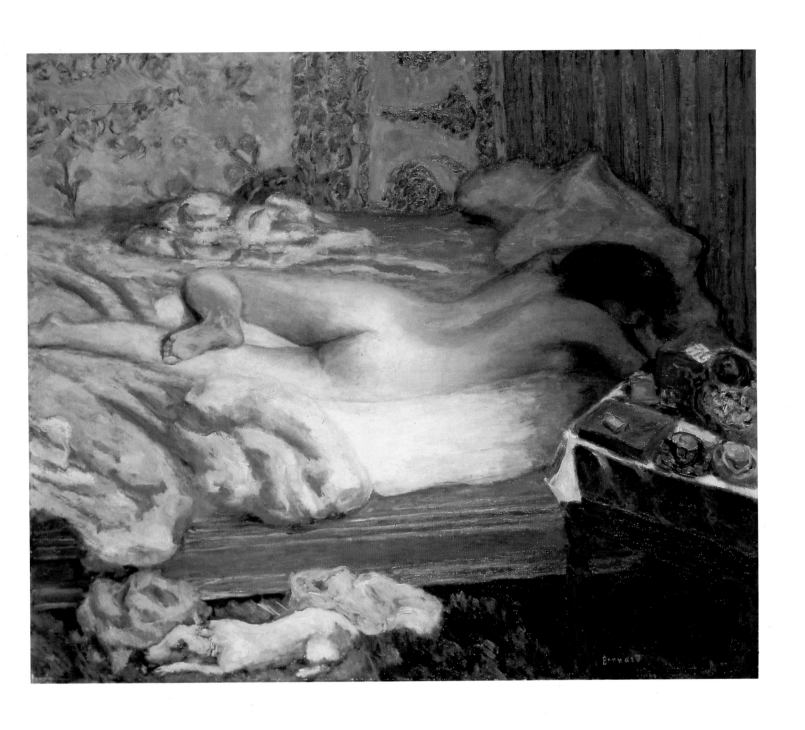

Planche X 1900
La Sieste

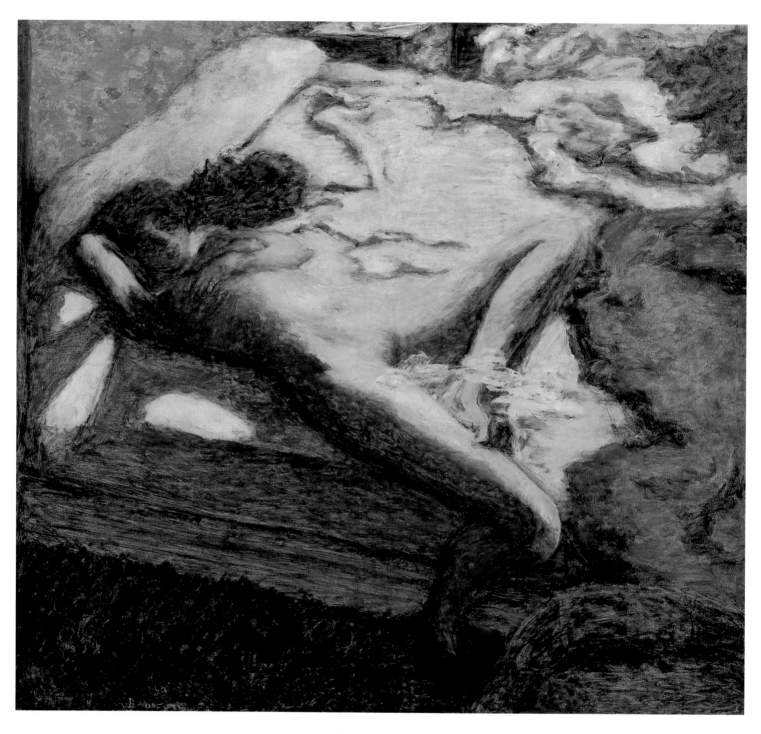

Planche IX 1899
L'Indolente

Planche XI 1900
L'Homme et la Femme

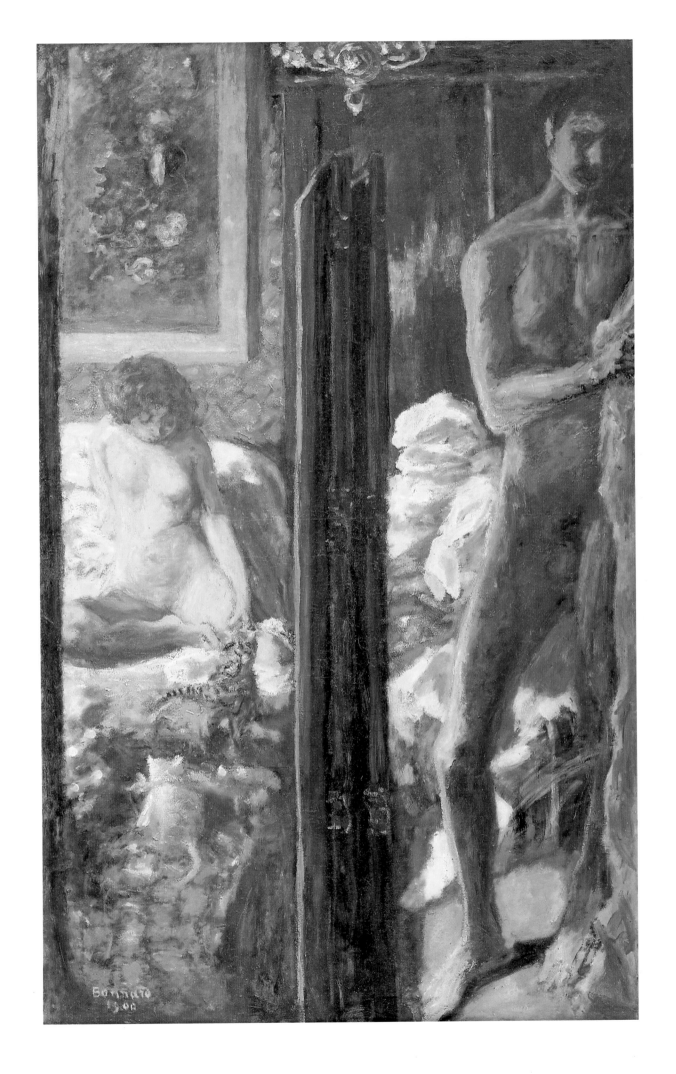

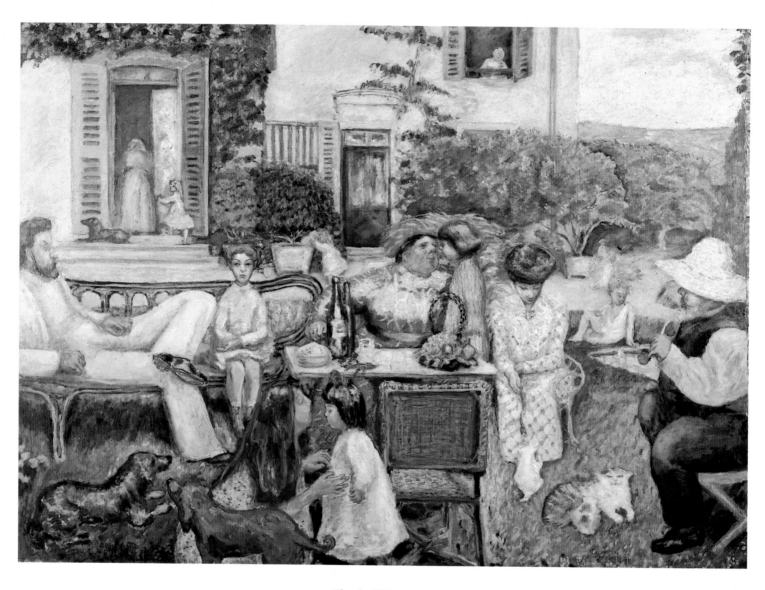

Planche XII *1900*
L'Après-midi bourgeoise *ou* La famille Terrasse

Planche XIII *circa 1902-1903*
Portrait de Claude Terrasse

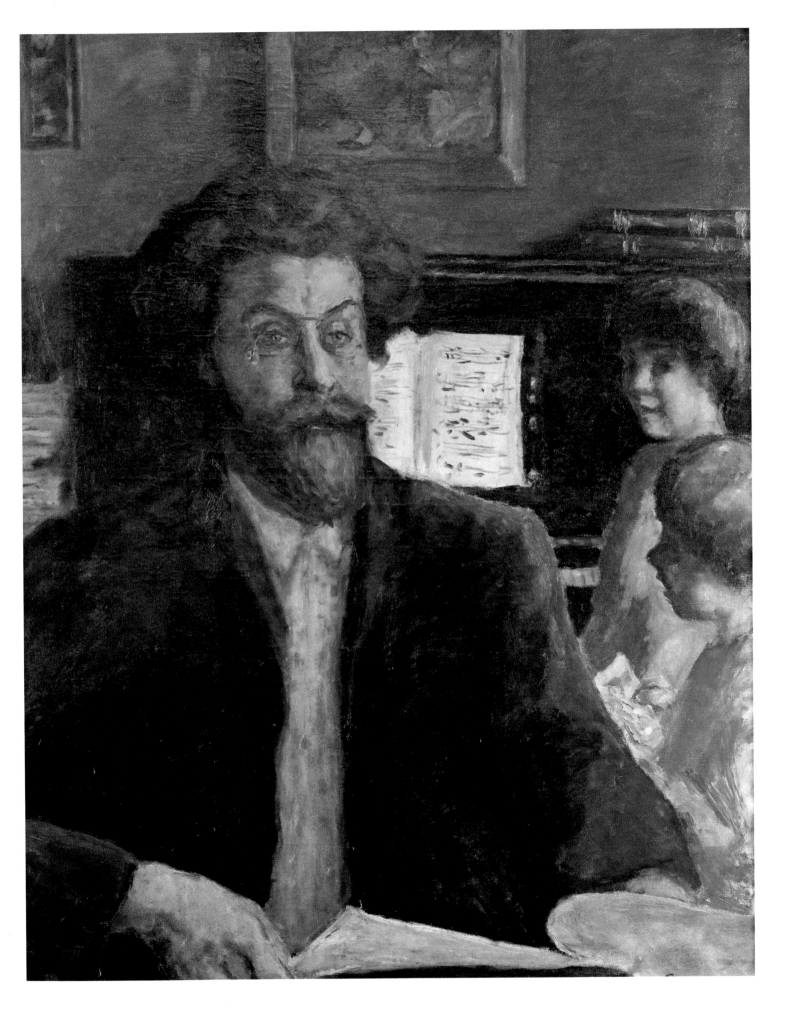

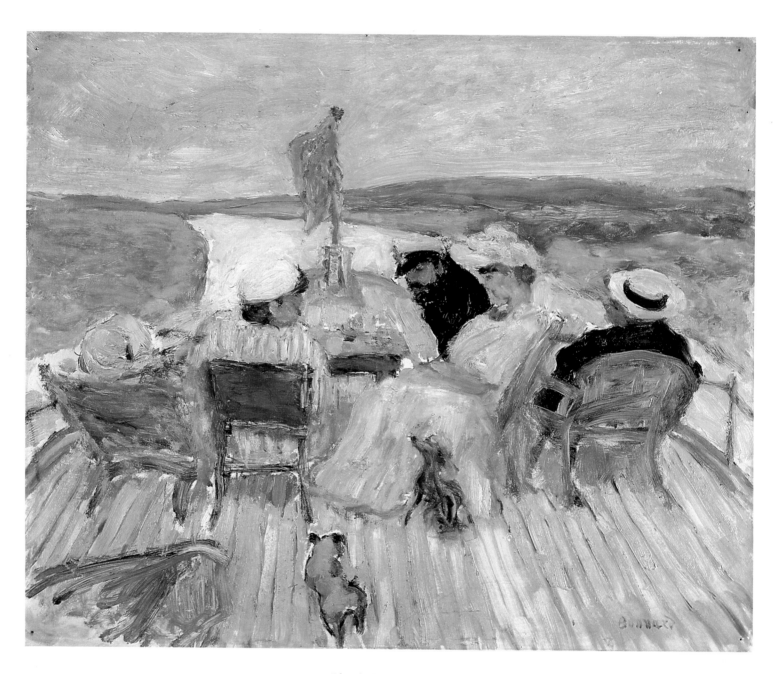

Planche XIV circa 1906
Sur le yacht d'Edwards

Planche XV circa 1916
Nu au tub

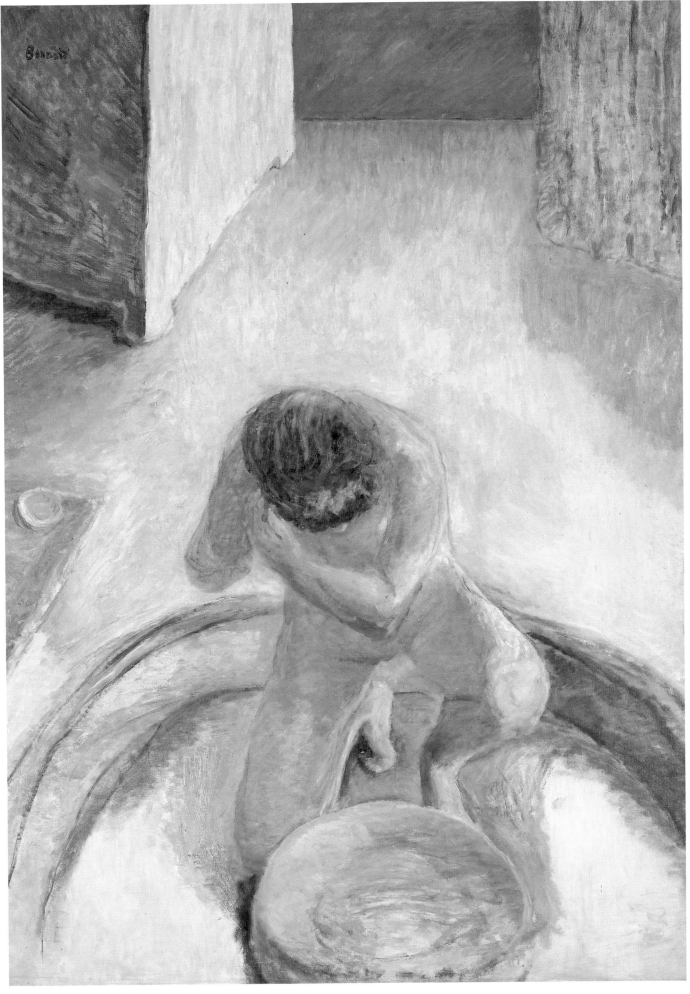

107

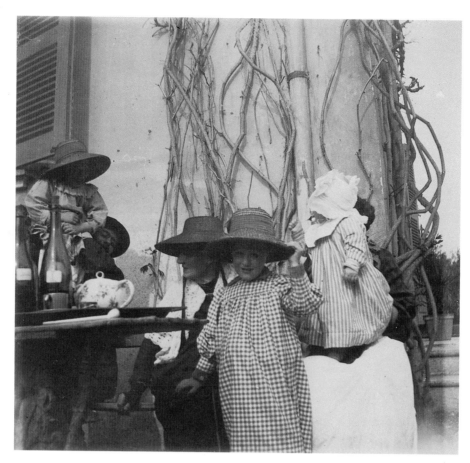

Planche XVI 1900
Edouard Vuillard : Scène de famille au Grand-Lemps

Planche XVI 1900
Edouard Vuillard : Bonnard chatouillant Renée

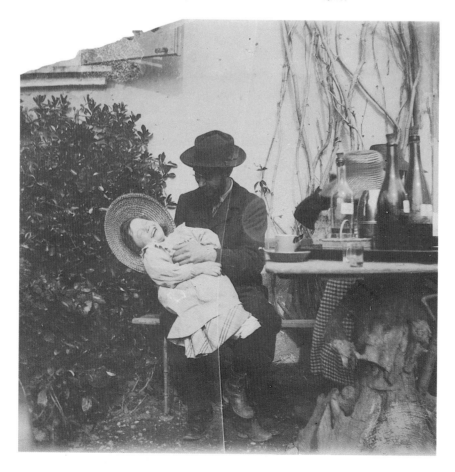

Catalogue

This catalogue assembles all of the photographs by Pierre Bonnard that have been passed down to the descendants of his nephew, Charles Terrasse. The collection consists of 155 prints and 106 negatives. [1] During his first period of photographic activity, from 1891 to 1906 (cat. nos.1–211), Bonnard used a very small format camera with tiny negatives (3.8 × 5.5 cm; $1\frac{1}{2}$ × 2 in.). [2] He can be seen holding this camera in a photograph taken by Vuillard in 1899 (H.C. 3; fig. 14). After about 1907-08, Bonnard used a different camera (the exact model is unknown) and the rare surviving negatives of his production up until 1916 (cat. nos. 212-222) are larger (5.5 × 8.0 cm; $2\frac{1}{4}$ × $3\frac{1}{4}$ in.). The negatives dating from the first period are often of very good quality, allowing considerable enlargement (which Bonnard apparently never tried), but some of them are under- or over-exposed or veiled. The negatives of the second period produced more precise and monumental images, but many of the images are streaked, either due to a defect in the camera or, more likely, to mishandling in development.

The vintage prints are generally contact prints in either albumen or gelatin-silver. The prints produced from the smaller negatives were often separated from one another (like the negatives of this category) only after having been printed in strips. Several sheets survive with strips of two images (the negatives are almost always still joined) or four images (two bands of two joined negatives). [3] The other prints made from small negatives, in gelatin-silver or citrate paper, are slightly enlarged and appear on separate sheets; these prints are either loose or pasted onto pages of a notebook, sometimes bearing handwritten inscriptions by Bonnard. Besides the contact prints of large negatives, there are also a few enlargements on rather mediocre silver paper.

The condition of the negatives and, particularly, many of the prints (many are badly fixed) demonstrates that they were originally processed by an amateur lacking experience in photography. Was it Bonnard himself? More likely it would have been another member of his circle of friends and family. For nothing indicates that the artist ever possessed even a small photographic laboratory and no written source or family tradition mentions Bonnard's involvement in the developing or printing of his photographs.

The 222 photographs presented in this catalogue constitute a significant portion of Bonnard's photographic output, though it is impossible to establish a precise quantitative total. For example, it can be noted that there are no surviving prints of many of the negatives, although these certainly must have been printed at the time. Moreover, it seems difficult to believe that Bonnard did not have available a print of *Marthe bathing* (cat. no. 214; pl. 59), when he repeated this composition, without modification, in several canvases. Yet, no contemporary print of this image survives. On the other hand, the negatives of numerous prints have disappeared. Thus, it can be reasonably assumed that an indeterminate quantity of Bonnard's photographs, negatives, and original prints have not survived. What else would explain the fact that there are no photographs between 1891 and 1897, that only ten images survive from the years between 1908 and 1916, and that certain themes seem less than fully developed (e.g., the trips with friends, the bathing scenes of 1903, etc.)? Most likely many of Bonnard's photographs were scattered, lost or discarded during his frequent changes of address.

The attribution of photographs to Bonnard and constitution of this catalogue are based on various technical and stylistic critera (see the Introduction). First of all, there is the family tradition that originates from the memories of Charles Terrasse, one of Bonnard's favorite models in the photographs. In addition, the nature of the prints

produced from negatives from Bonnard's camera has often been a determinant. As we note, however, other people besides Bonnard used this camera and so we have also included certain photographs in which Bonnard appears, taken with his own camera, when it is obvious that they were taken during a session which he directed. We consider these photographs self-portraits, for Bonnard has posed himself (see the series of nude self-portraits cat. nos. 136-139, where, at least for once, we can name the author). Further, an attentive examination of the photographs has allowed us to pinpoint Bonnard's own photographic "style," and many images have been included in this catalogue because they can be recognized as being in his "style." Finally, certain photographs of a different spirit were attributed to Bonnard because they were obviously carried out as part of a series or belonged to a group of images that are characteristic of his style (see chap. 6). At the same time, a whole series of photographs in the Bonnard archives has been excluded because the technical aspects of the prints and their negatives and, in particular, the style of the images seemed alien to Bonnard's way of thinking.

The catalogue has been organized chronologically and by themes, often corresponding to Bonnard's visits to various places in France and abroad. Dating the photographs was sometimes problematic, as is often the case with the artist's paintings; most of the discrepancies in dates, however, involve a difference of only one or two years. Certain dates are based on family tradition, others are derived from actual research; some can be established by reference to paintings whose dates are provided in Jean and Henry Dauberville's catalogue raisonné of Bonnard's work.

The chapter introductions explain the constitution of the various series, justify the proposed dates, comment on the artist's visits and voyages, and establish connections between photographs, paintings, and prints. The photographs by Vuillard at the end of the catalogue were given by him to Bonnard.

1. There are 74 negatives without original prints; 30 negatives with one print; 2 negatives with two prints; 69 contact prints whose negatives have disappeared; 38 enlargements originating from small negatives that have also disappeared; and 14 photographs with two or three prints without negatives.

2. A Kodak pocket-model 96.

3. The grouping of images in strips of contact prints is indicated in the catalogue entries. The combination of two negatives indicates the order of the shots. However, there are not enough contact sheets to constitute a real point of reference for establishing the order of images belonging to the same series. Therefore, for the most part, the order of the images is based on other criteria. When a sheet contains four photographs, the first number in the entry indicates the image that is joined on the strip to that of the entry; the second and third numbers relate to the images on the second strip, which in general correspond to a different series from the first. Their being brought together might nevertheless suggest dates that are close to those of the principal photograph.

N.B.: Unless otherwise indicated, the dimensions of the negatives are 3.8 × 5.5 cm. (app. $1\frac{1}{2}$ × 2 in.). The dimensions of the negatives and prints are given in centimeters and inches height by width.
Abbreviations; cf. = confer; fig. = figure; pl. = plate.
The letter "D" followed by a number, refers to Jean and Henry Dauberville, *Bonnard : Catalogue raisonné de l'œuvre peint*, 4 vols. (Paris : Editions J. et H. Bernheim-Jeune, 1965-74).

CONTENTS OF THE CATALOGUE

Chapter 1 : Berthe Schaedlin - circa 1891 (no. 1)

Chapter 2 : The Terrasse Children in the Dining Room - 1897 (no. 2)

Chapter 3 : Noisy-le-Grand, Domestic Scenes - 1898 and 1899 (nos. 3-38)

Chapter 4 : Grand-Lemps, Family Scenes - 1898 (nos. 39-43)

Chapter 5 : Grand-Lemps, Bathing Scenes - Summer 1899 (nos. 44-60)

Chapter 6 : Grand-Lemps, Scenes with Vivette - August 1899 (nos. 61-71)

Chapter 7 : Pierre Bonnard, Edouard Vuillard and Ker-Xavier Roussel visit Venice - 1899 (nos. 72-79)

Chapter 8 : Grand-Lemps, Fruit picking - 1899-1900 (nos. 80-85)

Chapter 9 : Grand-Lemps, Family Scenes - 1899-1900 (nos. 86-99)

Chapter 10 : Grand-Lemps, visits by Edouard Vuillard and Ker-Xavier Roussel - Spring 1900 (nos. 100-107)

Chapter 11 : Nudes of Marthe in Bonnard's Parisian apartment - circa 1899-1900 (nos. 108-117)

Chapter 12 : Nudes of Marthe and Bonnard in a garden at Montval - 1900-1901 (nos. 118-139)

Chapter 13 : Pierre Bonnard, Edouard Vuillard and Antoine and Emmanuel Bibesco in Spain - Early 1901 (nos. 140-147)

Chapter 14 : Grand-Lemps, A Visit from Thadée Natanson, Misia and Ida Godebska - 1902 (no. 148)

Chapter 15 : Various family scenes at Montval - circa 1902 (nos. 149-168)

Chapter 16 : Paris, Family scenes in Bonnard's studio, rue de Douai - circa 1902-03 (nos. 169-172)

Chapter 17 : Grand-Lemps, Henri Jacotot's visit - circa 1902-03 (nos. 173-183)

Chapter 18 : Two figures in the countryside - circa 1903 (nos. 184 and 185)

Chapter 19 : Grand-Lemps, Family scenes and bathers - 1903-05 (nos. 186-194)

Chapter 20 : Grand-Lemps, The "Clos" – date unknown (nos. 195 and 196)

Chapter 21 : Nude model in Bonnard's Parisian studio - circa 1905 (nos. 197-201)

Chapter 22 : Visit to the seaside - July 1904 or August 1906 (?) (nos. 202-204)

Chapter 23 : Cruise on the yacht Aimée - July-August 1906 (nos. 205-211)

Chapter 24 : Sojourn at Vernouillet (Médan or Villènnes ?) - circa 1907-10 (nos. 212-214)

Chapter 25 : Sojourn at Vernonet - 1910-15 (nos. 215-218)

Chapter 26 : A Model in the artist's studio - circa 1916 (nos. 219-222)

Chapter 27 : Portrait of Renoir attributed to Bonnard - circa 1916 (nos. 223-224)

Appendix : Photographs by Edouard Vuillard taken at Grand-Lemps - Spring 1900

By comparing this photograph with a drawing, [4] Antoine Terrasse (Bonnard's grand-nephew) recognized the profile of Berthe Schaedlin, Bonnard's cousin, who visited the family property at Grand-Lemps up until 1892. [5] The young woman also appears in profile in several of Bonnard's early canvases, in particular the two panels of *Femmes au jardin* of 1891 (D.0176, Musée d'Orsay), entitled *Femme à la pèlerine* and *Femme à la robe quadrillée*. Schaedlin is seen from the back, her face in profile, in the foreground right of *Partie de croquet* (or *Crépuscule*) of 1892, also in the Musée d'Orsay (D.38; pl. VIII).

At one point Bonnard had contemplated marrying Berthe Schaedlin, but in late 1893 he met Maria Boursin, called Marthe, who became his lifelong companion. This photograph of Schaedlin seems to date from 1890 or 1891 and is the first known example of Bonnard's photographic activity. It was taken during a bicycle ride, probably in the park at Grand-Lemps. The young woman poses near her bicycle; Bonnard's bicycle is leaning against a bush behind her.

In 1943, while composing the fictitious letter for Tériade, Bonnard still retained a vivid memory of his cousin Berthe picking fruit from the trees at Grand-Lemps. [6]

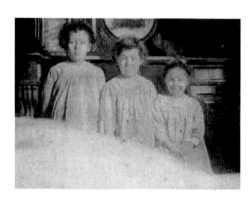

1 - Berthe Schaedlin during a bicycle ride
Original print, 3.8 × 5.1 cm
($1\frac{1}{2}$ × 2 in.)

4. Claire Frèches-Thory, "Pierre Bonnard : tableaux récemment acquis par le musée d'Orsay." *La Revue du Louvre* (Paris), 36 ann., no. 6 (1986), p. 418, figure 4.

5. Cf., chap. 4.

6. Cf., chap. 5.

Chapter 2: The Terrasse Children in the Dining Room — 1897

Judging from the ages of the children, this photograph of Jean, Charles, and Renée Terrasse is earlier than the first images taken at Noisy-le-Grand in 1898, and might therefore be dated 1897. The dining room is probably in the Terrasse's Parisian apartment at 6, rue Ballu, where they lived until 1902.

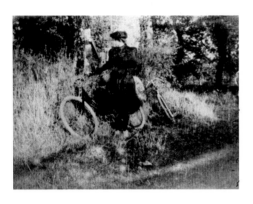

2 - Jean, Charles, and Renée posing behind a table
Original print, 3.8 × 5.2 cm ($1\frac{1}{2}$ × 2 in.)

Chapter 3: Noisy-le-Grand, Domestic scenes — 1898 and 1899

From 1897 to 1899, the Terrasse family rented for short vacations a house with a large garden at Noisy-le-Grand, near Paris. The Bonnards, Pierre and Charles, along with the Prudhommes also visited Noisy-le-Grand. One group of photographs taken at Noisy-le-Grand forms a coherent series (cat. nos. 3-30), and dates from 1898. This date is based on the presence of little Marcel Terrasse, who died in 1898, at the age of one-and-a-half. Another group must date from the following year, since Vivette (born April 11, 1899) appears in them as a newborn baby on the lap of Madame Mertzdorff (no. 35). (In fact, in photographs of the earlier group, Andrée Terrasse appears pregnant, e.g., cat. nos. 3 and 4.) A third group (cat. nos. 31-36) was obviously taken at the same time and therefore can also be dated 1899.

It is difficult today to have a clear idea of what the garden at Noisy-le-Grand was like, since Bonnard never painted it. However, several photographs (cat. nos. 19 and 21-24), obviously forming a group with the rest of the series, allow us to have a glimpse of various parts of the yard. In one photograph (cat. no. 21), the pale-colored façade of the house is visible with its distinctive wide, dark string-course in the lower part. The same tree can be seen in three photographs (cat. nos. 21, 22, and 24). At least once, Bonnard painted the façade of Noisy-le-Grand (see cat. no. 30).

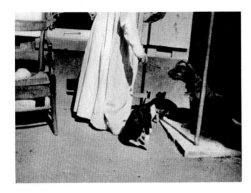

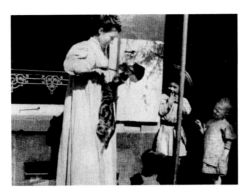

3 - Andrée Terrasse playing with two cats
and a dog
Original negative
Plate 18

4 - A cat leaping onto Andrée Terrasse's
dress, to the amusement of Renée and
Robert
Original negative
Plate 19

5 - A striped cat leaping into the under-
brush
Original negative
Plate 22

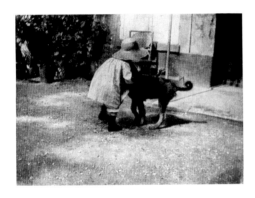

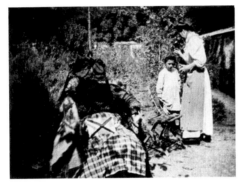

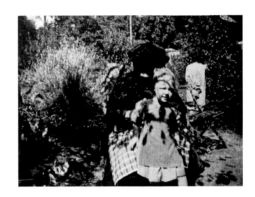

6 - Renée (?) hugging a dog
Original negative
Plate 28

7 - Madame Mertzdorff, Andrée and Jean
Terrasse
Original negative
Plate 20

8 - Madame Mertzdorff, Robert, and
Charles, who has his back to the
camera
Original negative
Plate 21

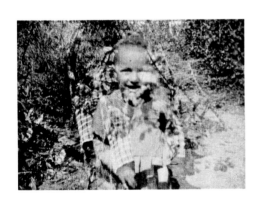

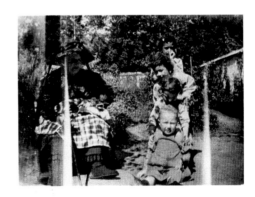

9 - Madame Mertzdorff and Robert
Original negative
Double exposure (probably taken at the
same time as cat. no. 8).

10 - Madame Mertzdorff and Robert
Original negative
Double-exposure

11 - Madame Mertzdorff and, from front to
back, Robert, Renée, Jean, and Charles
Terrasse
Original negative

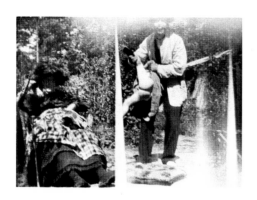

12 - Madame Mertzdorff and Pierre Bonnard, who is holding Robert upside down
Original negative

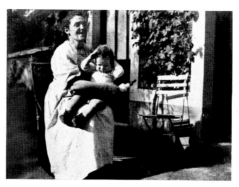

13 - Marcel and his nursemaid
Original negative
Plate 24

14 - Marcel Terrasse
Original negative
Plate 26

15 - Marcel Terrasse
Original negative

16 - Marcel Terrasse
Original negative

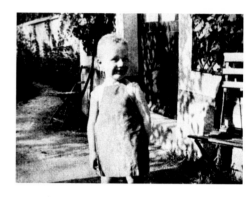

17 - Robert Terrasse
Original negative

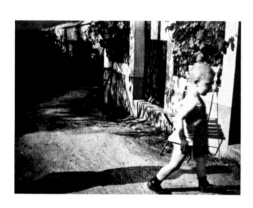

18 - Robert Terrasse
Original negative
Plate 25

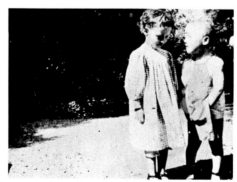

19 - Renée and Robert Terrasse
Original print, pasted onto a notebook page with cat. nos. 27, 30, 22, and 24, 3.4 × 5.2 cm (1 3/8 × 2 1/16 in.)
Plate 66

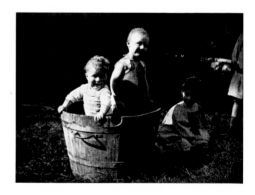

20 - Marcel and Robert in a bucket; Renée seated next to them with fourth child who is cropped at the edge of the photograph
Original negative
Plate 27

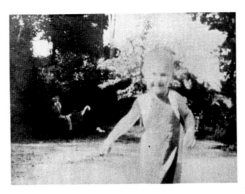

21 - Marcel crawling in the garden
Original print, 3.6 × 5.1 cm
(1 $\frac{7}{16}$ × 2 in.)

22 - Robert Terrasse
Two original prints, one pasted onto a notebook page with cat. nos. 27, 30, 19, and 24, 3.3 × 5.3 cm (1 $\frac{5}{16}$ × 2 $\frac{1}{8}$ in.) and 3.8 × 5.2 cm (1 $\frac{1}{2}$ × 2 $\frac{1}{16}$ in.)

23 - The family dog approaches the camera while the Terrasse children look on
Original negative
Plate 23

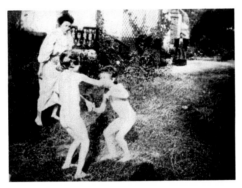

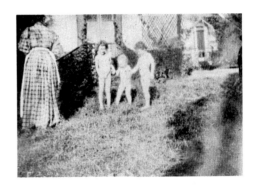

24 - Charles and Jean Terrasse
Original print, pasted onto a notebook page with cat. nos. 27, 30, 22, and 19, 3.8 × 5.7 cm (1 $\frac{1}{2}$ × 2 $\frac{1}{4}$ in.)

25 - Jean and Charles dancing: behind them is Andrée Terrasse and on the far right is Madame Eugène Bonnard
Original print, 3.8 × 5.0 cm
(1 $\frac{1}{2}$ × 2 in.)
Plate 63

26 - Jean, Robert, and Charles Terrasse posing to the right of their nursemaid
Original print, 3.7 × 5.4 cm
(1 $\frac{1}{2}$ × 2 $\frac{1}{8}$ in.)

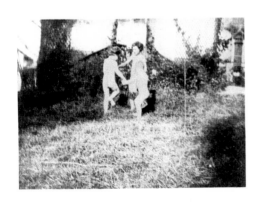

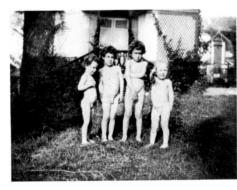

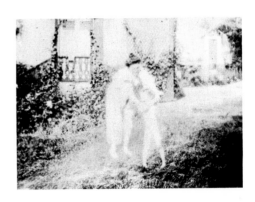

27 - Three Terrasse children dancing
Original print, pasted onto a notebook with cat. nos. 30, 22, 19, and 24, 3.7 × 5.5 cm (1 $\frac{1}{2}$ × 2 $\frac{3}{16}$ in.)
For both cat. nos. 25 and 27, see figure 3, *Les Trois Enfants nus* (D.194), according to Charles Terrasse dating from Summer 1899.

28 - Renée, Charles, Jean and Robert Terrasse
Original print, 3.8 × 6.0 cm
(1 $\frac{1}{2}$ × 2 $\frac{3}{8}$ in.)

29 - Andrée Terrasse and one of her children
Original print, 3.8 × 5.0 cm
(1 $\frac{1}{2}$ × 2 in.)

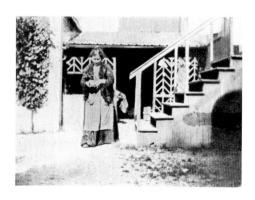

30 - Madame Eugène Bonnard
Original print, pasted onto a notebook page with cat. nos. 27, 22, 19, and 24. 3.6 × 5.0 cm (1 7/16 × 2 in.)
This photograph is related to a canvas erroneously entitled *Cour de ferme* (D. 168), which represents the same place and is dated c. 1898.
Plate 77

31 - Madame Mertzdorff and Charles Bonnard
Original negative

32 - Charles Bonnard, Renée Terrasse, and a dog
Original negative

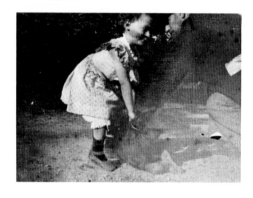

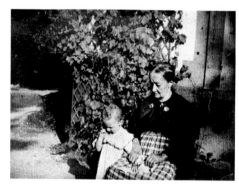

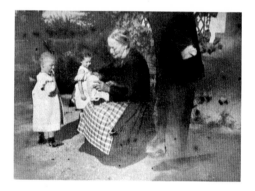

33 - Charles Bonnard and Renée Terrasse petting a dog
Original negative

34 - Madame Mertzdorff and Robert Terrasse
Original negative

35 - Madame Mertzdorff holding Vivette Terrasse, Charles Bonnard, and Robert and Renée Terrasse in the background
Original negative

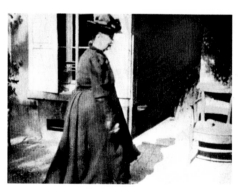

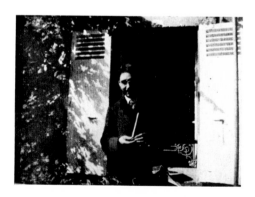

36 - Renée Terrasse
Original negative
Plate 29

37 - Madame Prudhomme
Original print, printed on the same sheet as cat. no. 38, 3.8 × 5.0 cm (1 1/2 × 2 in.)

38 - Pierre Bonnard (self-portrait)
Original print, printed on the same sheet as cat. no. 37, 3.8 × 5.0 cm (1 1/2 × 2 in.)

Le "Clos" at Grand-Lemps, in the Dauphine, was the family property of Bonnard's parents, where Pierre, Charles and the Terrasse family went regularly. Friends of the painter and the musician were also frequent visitors: Edouard Vuillard and Ker-Xavier Roussel (see chap. 10), Thadée and Misia Natanson (see chap. 14), Franc-Nohain and his children, Antoine Lumière and his sons, Maurice Donnay, Alfred Jarry, George Courteline, and others. Marthe did not visit Grand-Lemps before 1913.

The property included a meadow, an orchard, and a huge garden encircling the house (see chap. 20), decorated with nine ponds, which were, in turn, the theater for photographs (see chap. 5). Grand-Lemps has, in fact, a prominent place in the work of Pierre Bonnard, both in relation to his canvases (he painted many there), his drawings (between 1892 and 1895 he had partially completed, in collaboration with Claude Terrasse, "Le Solfège" and "Petites scènes familiares") and of course his photographs. We have regrouped these in different chapters, following the outline and the chronology. In this particular series, the Terrasse children (Marcel is still present) are clearly the same age as in the preceding series.

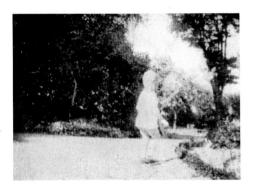 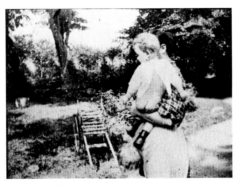 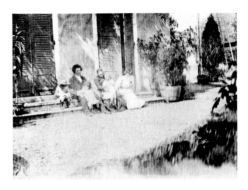

39 - Robert walking, seen from behind
Original print, 3.6 × 5.2 cm
($1\frac{1}{16}$ × 2 in.)

40 - Marcel in the arms of his nurse
Original print, 3.8 × 5.0 cm
($1\frac{1}{2}$ × 2 in.)

41 - Claude Terrasse and two of his children with Madame Prudhomme holding Robert on her knees and Andrée Terrasse
Original print pasted onto a notebook page with no. 195, 5.7 × 8.3 cm
($2\frac{1}{4}$ × $3\frac{1}{4}$ in.)

42 - Cat with two-tone fur (see cat. no. 3) standing on a bed
Original print, 4.4 × 5.5 cm
($1\frac{1}{8}$ × $2\frac{1}{8}$ in.)

43 - Cat with two-tone fur sleeping on a bed
Original print, 3.8 × 5.4 cm
($1\frac{1}{2}$ × $2\frac{1}{8}$ in.)

Chapter 5: Grand-Lemps, Bathing Scenes — Summer 1899

In the youthful letters recomposed for Tériade around 1943,[7] Bonnard imagined a letter written to his brother Charles, then in the military, describing his arrival at the "Clos": "I hope that next Sunday you can get leave and can join us. It's incredibly hot. So we all take a dip, the little ones in the pool in front of the house and the adults in the boutasse. The kids playing in the pool is so delightful."[8]

These scenes were repeated many times over the next several years, much to Bonnard's delight. But in 1899, in particular, the artist painted a whole series of canvases of children swimming in the pools. The octagonal pool photographed by Bonnard (no. 173) can be seen in two of these paintings, both bearing the title *La Baignade au Grand-Lemps* (D.191 and D.192; figs. 4 and 5). Several photographs (cat. nos. 45-48) show the pool with a fountain situated in front of the facade of the "Clos" and seen in *Enfants au bassin*, 1899 (D.01797; fig. 6). The "boutasse" was the round pool located near the vegetable garden shown in one photograph (cat. no. 44) and later painted by Bonnard.[9]

The photographs in this chapter obviously date from the same year, as confirmed by the ages of the children. But even if the same interest prompted Bonnard to paint and to photograph this motif, there are no formal relationships between the compositions in the two mediums. The only possible link is the device of using the pool on the lawn as the center of a symmetrical composition (cf., cat nos. 45 and 46 and figs. 4-6).

7. Cf., Chapter 1. The work edited by Tériade is, Pierre Bonnard, *Correspondances* (Paris : Éditions de la Revue Verve, 1944).

8. Ibid, p. 77.

9. Charles Terrasse, Bonnard (Paris : Henri Floury, 1927), p. 100. See the painting *Les Fleurs du potager (Le Grand-Lemps)*, 1909 (D.548).

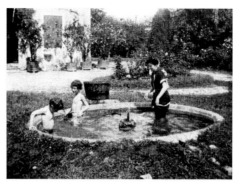

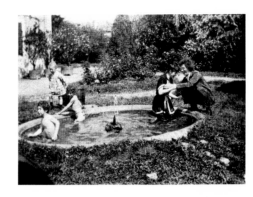

44 - The pool called "La Boutasse"
Original print, 3.3 × 4.8 cm
($1\frac{5}{16}$ × $1\frac{7}{8}$ in.)

45 - Charles, Jean, and Andrée Terrasse
Original negative
Plate 34

46 - Charles, Robert, Jean, Andrée, and
Claude Terrasse
Original negative
Plate 35

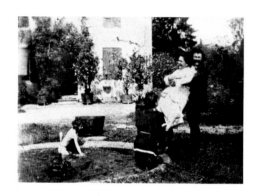

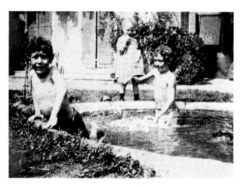

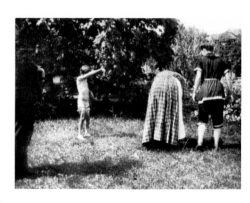

47 - Claude Terrasse clowning with a friend
Charles, another child, and Andrée Ter-
rasse looking on
Original print, printed on the same
sheet as cat. no. 48 and pasted onto a
notebook page with cat. nos. 54 and
59, 3.6 × 5.0 cm ($1\frac{7}{16}$ × 2 in.)
Inscription on verso of notebook page
in Bonnard's handwriting: *Lemps.*

48 - Charles, Robert, and Jean Terrasse
Original print, printed on the same
sheet as cat. no. 47 and pasted a
notebook page with nos. 54 and 59,
3.6 × 5.2 cm ($1\frac{7}{16}$ × 2 in.)

49 - Claude, Andrée, and Charles Terrasse
with a nursemaid
Original negative
Plate 32

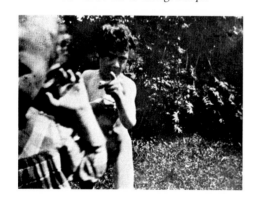

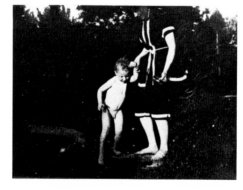

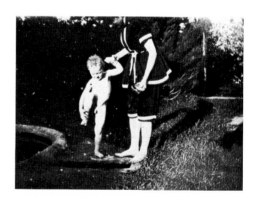

50 - Cropped close-up of Robert Terrasse
with his brother Charles in the
background
Original print, printed on the same
sheet as cat. no. 53, 3.8 × 5.3 cm
($1\frac{1}{2}$ × 2 in.)
Plate 62

51 - Andrée and Robert Terrasse
Original print, printed on the same
sheet as cat. no. 52, 3.8 × 5.1 cm
($1\frac{1}{2}$ × 2 in.)

52 - Andrée and Robert Terrasse
Original print, printed on the same
sheet as cat. no. 51, 3.7 × 5.2 cm
($1\frac{1}{2}$ × 2 in.)

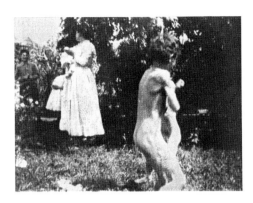

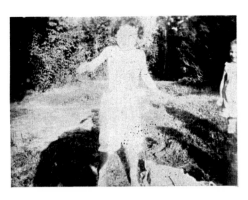

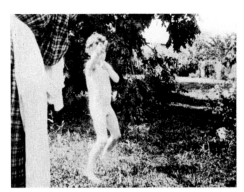

53 - Jean playing with another child, while others look on in the background
Two original prints, one (image reversed) printed on the same sheet as cat. no. 50, 3.7 × 5.2 cm (1½ × 2 in.) and 3.3 × 5.1 cm (1 5/16 × 2 in.)

54 - Jean (full face) and Renée Terrasse (cropped at the left) and shadows of others
Original print, printed on the same sheet as cat. no. 59 and pasted into a notebook page with cat. nos. 47 and 48, 3.7 × 5.2 cm (1½ × 2 in.)

55 - Charles Terrasse and his nursemaid (cropped)
Original print, 3.9 × 5.1 cm (1½ × 2 in)
The child's pose served as the model for the cover illustration of René Boylesve's *La Leçon d'Amour dans un parc*, 1902 (Plate VI)
Plate 72

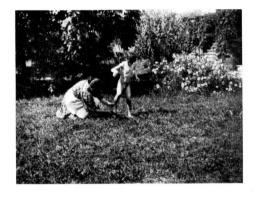

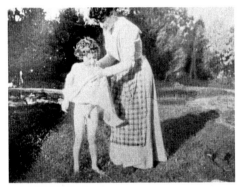

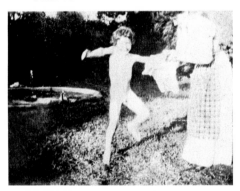

56 - Charles Terrasse and a nursemaid
Original negative
Plate 33

57 - Andrée Terrasse drying Charles
Original print, printed on the same sheet as cat. no. 58, 3.8 × 5.4 (1½ × 2½ in.)
Plate 70

58 - Andrée Terrasse drying Charles, who executes a dance movement
Original print, printed on the same sheet as cat. no. 57, 3.9 × 5.1 cm (1½ × 2 in.)
Plate 71

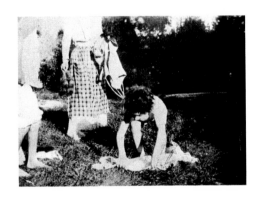

59 - Charles, Andrée, and Jean Terrasse
Original print, printed on the same sheet as cat. no. 54 and pasted onto a notebook page with cat. nos. 47 and 48, 3.8 × 5.0 cm (1½ × 2 in.)
Plate 73

60 - Pierre Bonnard by the side of the pool playing with Renée, while a nursemaid holds Robert, and Charles and Jean Terrasse sit in the pool (Andrée Terrasse is cropped at the left)
Original print, 5.6 × 7.7 cm (2 3/16 × 3 in.)

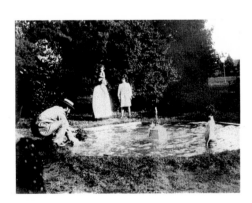

Chapter 6: Grand-Lemps, Scenes with Vivette – August 1899

Eugénie, nicknamed Vivette, the Terrasse's sixth child, was born on April 11, 1899. Vivette appeared in an earlier photograph (cat. no. 35), held on her great-grandmother's lap at Noisy-le-Grand. The following series of photographs was taken during the summer of the same year at Grand-Lemps. In addition to the Terrasse family, one finds Grandmother Mertzdorff and the Prudhomme cousins. The goat visible in two photographs (cat. nos. 69 and 70) was to provide milk for Vivette who was allergic to cow's milk.

The style of the photographs in this group is on the whole rather drier, more precise, and serious than is typical of Bonnard's camera; the difference in size is due to their having been enlarged. However, despite this, certain photographs (cat. nos. 63 and 67-69) directly linked to the rest of the series, are so characteristic of Bonnard's style that there is no reason not to admit that the whole series was by him.

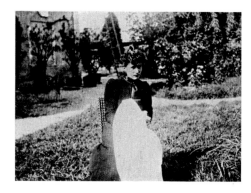

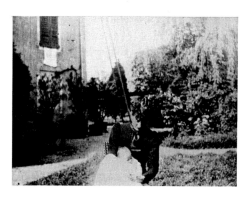

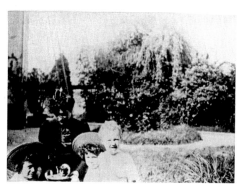

61 - Andrée Terrasse holding Vivette on her lap
Original print, 5.7 × 8.1 cm
($2\frac{1}{4}$ × $3\frac{1}{4}$ in.)

62 - Andrée Terrasse holding Vivette on her lap
Original print, 5.7 × 8.1 cm
($2\frac{1}{4}$ × $3\frac{1}{4}$ in.)

63 - Andrée feeding milk to a cat, with Jean, Charles, and Robert Terrasse
Original print, 5.7 × 8.1 cm
($2\frac{1}{4}$ × $3\frac{1}{4}$ in.)

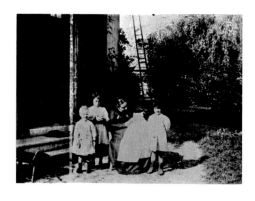

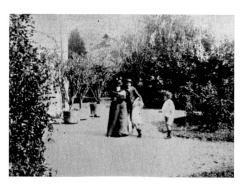

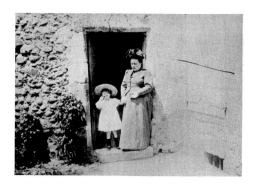

64 - Madame Prudhomme holding Vivette on her lap, surrounded by Robert, Jean, and Charles Terrasse
Original print, 5.7 × 8.3 cm
($2\frac{1}{4}$ × $3\frac{1}{4}$ in.)

65 - Madame Prudhomme, Pierre Bonnard holding Renée, and Charles Terrasse
Original print, 5.7 × 8.2 cm
($2\frac{1}{4}$ × $3\frac{1}{4}$ in.)

66 - Madame Prudhomme and Renée
Original print, 5.7 × 8.2 cm
($2\frac{1}{4}$ × $3\frac{1}{4}$ in.)

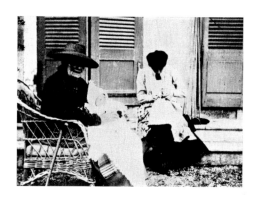

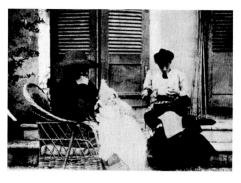

67 - Madame Mertzdoff holding Vivette on her lap, with Andrée Terrasse sewing
Original print, 5.8 × 8.0 cm
($2\frac{1}{4}$ × $3\frac{1}{4}$ in.)

68 - Madame Mertzdorff holding Vivette on her lap, with Andrée Terrasse sewing
Original print, 5.8 × 8.1 cm
($2\frac{1}{4}$ × $3\frac{1}{4}$ in.)

69 - Claude Terrasse holding a goat on a lead, Charles and Renée Terrasse, and, in the background, Madame Eugène Bonnard
Two original prints, each 5.7 × 8.2 cm
($2\frac{1}{4}$ × $3\frac{1}{4}$ in.)

70 - Claude Terrasse holding a goat on a lead, Renée and Robert Terrasse, and Madame Prudhomme shading herself with a parasol
Original print, 5.9 × 8.2 cm
($2\frac{5}{16}$ × $3\frac{1}{4}$ in.)

71 - Claude Terrasse and Doctor Guillermin in the doorway called the "castle gate"
Two original prints, each 5.7 × 8.0 cm
($2\frac{1}{4}$ × $3\frac{1}{4}$ in.)

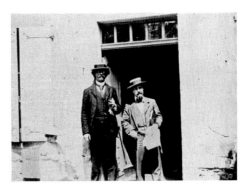

Chapter 7: Pierre Bonnard, Edouard Vuillard, and Ker-Xavier Roussel visit Venice – 1899

In 1899, Bonnard, Vuillard, and Roussel traveled to Venice, by way of Milan, the lakes, and Verona. Eight negatives by Bonnard (with two prints from these negatives) and a photograph taken by Roussel with Bonnard's camera (H.C.1) are all that remain as testimony to this voyage. As in the case of the trip to Spain (see chap. 13), it can be assumed that Bonnard took other photographs that have been lost.

Vuillard appears to be photographing Bonnard photographing him and Roussel in two images (plates 36 and 37; cat. nos. 72 and 73). Two of the photographs taken by Vuillard at this time are also included at the end of the chapter (H.C.2 and H.C.3).

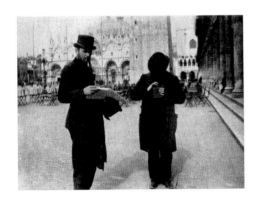

72 - Ker-Xavier Roussel and Edouard Vuillard, who is taking Bonnard's photograph; in the background is Saint Mark's Basilica
Original negative
Plate 36

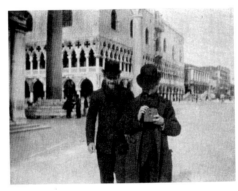

73 - Ker-Xavier Roussel and Edouard Vuillard, who is taking Bonnard's photograph; in the background is the Doge's Palace
Original negative
Plate 37

74 - Saint Mark's Square
Original negative

75 - Saint Mark's Square
Original negative

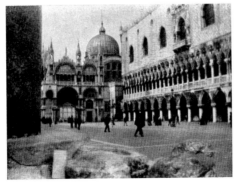

76 - Saint Mark's Square and the Doge's Palace
Original negative
Original print, printed on the same sheet as cat. no. 77, 3.5 × 5.1 cm
($1\frac{3}{8}$ × 2 in.)

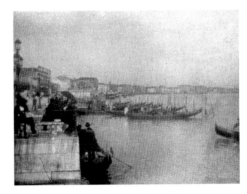

77 - The Quay of Slaves
Original negative
Original print, printed on the same sheet as no. 76, 3.5 × 5.1 cm
($1\frac{3}{8}$ × 2 in.)

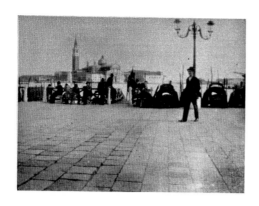

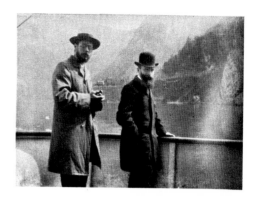

78 - View of San Giorgio Maggiore
Original negative
Related to a charcoal sketch by Bonnard (Private collection, Paris).
In one of Vuillard's photographs (H.C.2), Bonnard might be sketching San Giorgio.

79 - A Venetian canal
Original negative

H.C.1 - Ker-Xavier Roussel (with Bonnard's camera):
Bonnard and Vuillard on a boat on Lake Como or Lake Garda
Vintage print

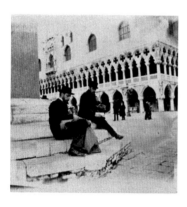

H.C.2 - Edouard Vuillard:
Bonnard and Roussel on the steps of the Piazzetta
Vintage print from the Vuillard archives

H.C.3 - Edouard Vuillard:
Roussel and Bonnard (holding his camera).
Vintage print from the Vuillard archives

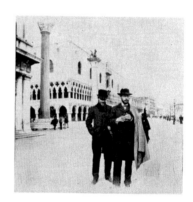

Chapter 8: Grand-Lemps, Fruit picking – 1899-1900

The scenes of fruit picking, repeated annually, were also described by Bonnard in his fictitious letters to his brother Charles, from Grand-Lemps: "The fruit is here in abundance. Mama makes the rounds every afternoon with her basket. Our cousin is a pretty sight, up in the peach tree, amidst branches and the blue sky..." [10]

Pierre Bonnard painted a series of canvases depicting fruit gathering at Grand-Lemps around 1899 (D.189, D.190, D.200, and D.204). Although the contemporary photographic compositions have little relation to the paintings, their spirit nevertheless is very characteristic of Bonnard's art.

10. See chap. 5, n. 1, p. 77.

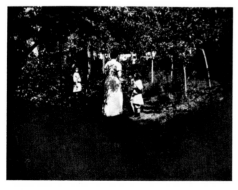

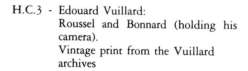

80 - Picking fruit: Andrée Terrasse, an unknown child, and in the background, Renée
Original negative
Plate 31

81 - Andrée and Renée Terrasse picking fruit
Original negative
Plate 30

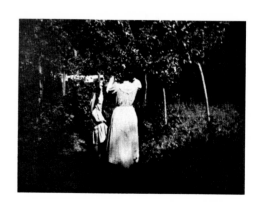

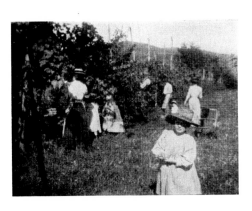

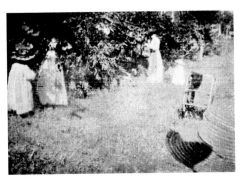

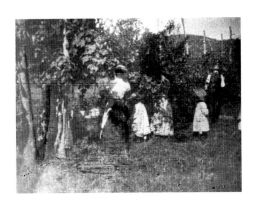

82 - Fruit picking, with various participants including Andrée Terrasse and, in the foreground, Renée
Original print, printed on the same sheet as cat. nos. 84, 97, and 98, 3.6 × 5.1 cm (1 $\frac{7}{16}$ × 2 in.)
Plate 68

83 - Fruit picking, with Andrée Terrasse and others (in extreme foreground a straw hat)
Original print, printed on the same sheet as cat. nos. 85, 97, and 98, 3.6 × 5.2 cm (1 $\frac{7}{16}$ × 2 in.)
Plate 69

84 - Fruit picking
Original print, printed on the same sheet as cat. nos. 82, 97, and 98, 3.9 × 5.0 cm (1 $\frac{9}{16}$ × 2 in.)

85 - Fruit picking
Original print, printed on the same sheet as cat. nos 83, 97, and 98, 3.7 × 5.2 cm (1 $\frac{1}{4}$ × 2 in.)

Chapter 9: Grand-Lemps, Family scenes – 1899-1900

This chapter assembles photographs of diverse scenes taken at Grand-Lemps around 1899-1900, but treating themes that are different from those of earlier chapters (e.g., bathing, fruit-picking).

Andrée Terrasse is seen standing alone, against a hedge in a few images (cat. nos 86 and 87). This pose recalls a painting entitled *Jeune femme dans un paysage*, 1892 (D.37). One pair of photographs (cat. nos. 89 and 92) could also have been integrated with the series concerning Vivette (chap. 6), and another pair (cat. nos. 96 and 98) could extend the fruit-picking series (chap. 8).

Finally, the admirable scene around a table (cat. no. 99), with the façade of Grand-Lemps in the background, depicts a theme that was very dear to Bonnard.

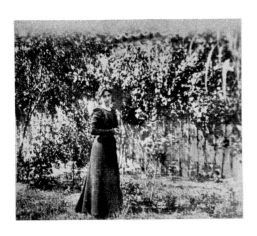

86 - Andrée Terrasse before an arbor
Original print, printed on the same sheet as cat. no. 87 and pasted onto a notebook page with cat. nos. 91 and 92, 3.7 × 5.1 cm (1 $\frac{1}{2}$ × 2 in.)
Inscription on verso of notebook page in Bonnard's handwriting: *Moucherote*.
Plate 78

87 - Andrée Terrasse before an arbor
Original print, printed on the same sheet as cat. no. 86 and pasted onto a notebook page with cat. nos. 91 and 92, 3.8 × 5.1 cm (1 $\frac{1}{2}$ × 2 in.)

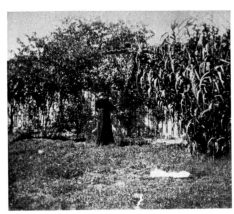

123

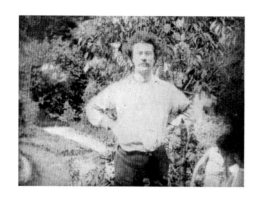

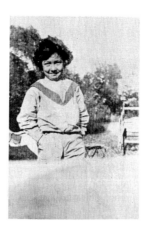

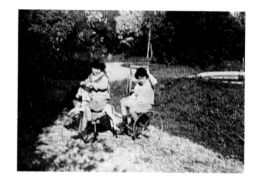

88 - Claude Terasse
 Original print, 3.5 × 5.5 cm
 ($1\frac{3}{8}$ × $2\frac{3}{16}$ in.)

89 - Charles Terrasse
 Original print, 8.6 × 5.6 cm
 ($3\frac{3}{8}$ × $2\frac{1}{4}$ in.)

90 - Charles and Jean Terrasse
 Original print, 5.0 × 8.1 cm
 (2 × $3\frac{1}{4}$ in.)

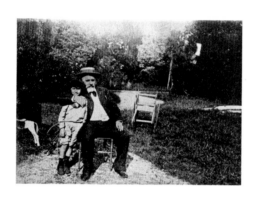

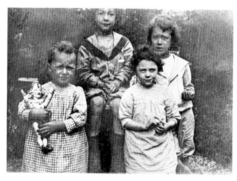

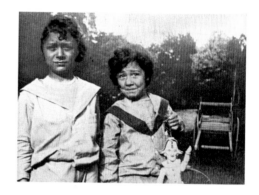

91 - Auguste Prudhomme and Charles Ter-
 rasse
 Two original prints, one pasted onto a
 notebook page with cat. nos. 86, 87,
 and 92, 5.6 × 8.0 cm ($2\frac{1}{4}$ × $3\frac{3}{16}$ in.)
 and 5.6 × 8.3 cm ($2\frac{1}{4}$ × $3\frac{1}{4}$ in.)

92 - Robert, Charles, Jean, and Renée Ter-
 rasse
 Original print, pasted onto a notebook
 page with cat. nos. 86, 87, and 91,
 5.8 × 8.5 cm ($2\frac{1}{4}$ × $3\frac{3}{8}$ in.)

93 - Jean and Charles Terrasse holding a
 marionette
 Original print, 5.7 × 8.1 cm
 ($2\frac{1}{4}$ × $3\frac{1}{4}$ in.)

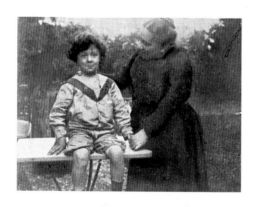

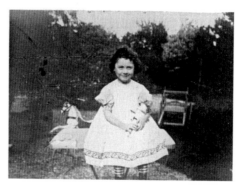

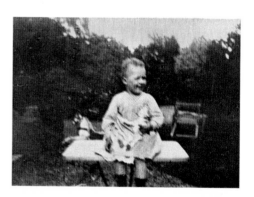

94 - Madame Eugène Bonnard and Charles
 Terrasse
 Original print, 5.7 × 8.2 cm
 ($2\frac{1}{4}$ × $3\frac{1}{4}$ in.)

95 - Renée holding a doll
 Original print, 5.7 × 8.1 cm
 ($2\frac{1}{4}$ × $3\frac{1}{4}$ in.)

96 - Robert holding a marionette
 Original print, 5.6 × 8.2 cm
 ($2\frac{1}{4}$ × $3\frac{1}{4}$ in.)

 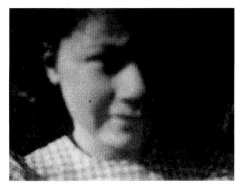 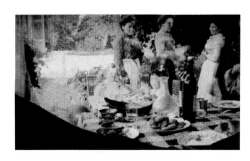

97 - Robert (holding his rifle "Eureka"), Charles (with his back to the camera), and Renée in the background
Two original prints, one printed on the same sheet as cat. nos. 98, 83, and 85, and the other printed on the same sheet as cat. nos. 98, 82, and 84, 3.8 × 5.2 cm (1$\frac{1}{2}$ × 2 in.) and 3.8 × 5.2 cm (1$\frac{1}{2}$ × 2 in.)
Plate 67

98 - Renée Terrasse
Two original prints, one printed on the same sheet as nos. 97, 83, and 85, and the other printed on the same sheet as nos. 97, 82, and 84.
Plate 76

99 - Table scene in the garden with various unidentified individuals
Original negative with fragment missing
Plate 61

Chapter 10: Grand-Lemps, Visits by Edouard Vuillard and Ker-Xavier Roussel — Spring 1900

Bonnard's close friends, the painters Vuillard and Roussel, joined him at this family property at Grand-Lemps in April-May 1900. This was the last time Grandmother Mertzdorff was photographed — she died on June 11, 1900.

Vuillard and Roussel's visit was recorded in photographs by both Bonnard and Vuillard (cf., Appendix Vuillard A-G and plates 81-85). One of Vuillard's pictures (pls. 81 and 82) shows Bonnard preparing to take Renée's photograph (cat. no. 103).

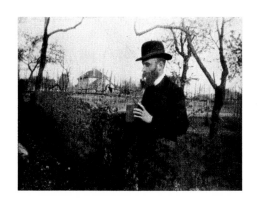 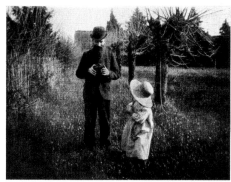

100 - Edouard Vuillard holding his Kodak
Original negative
Original print, printed on the same sheet as cat. no. 105, 3.8 × 5.5 cm (1$\frac{1}{2}$ × 2$\frac{3}{16}$ in.)
Plate 42

101 - Edouard Vuillard with his Kodak and a little girl
Original negative
Plate 38

102 - Renée looking at Pierre Bonnard
Original negative
Plate 40

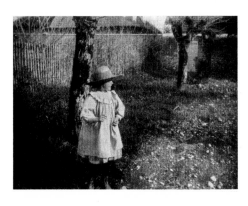

103 - Renée looking at Edouard Vuillard
Original negative
Plates 81 and 82
Plate 41
Cf., Vuillard's photograph showing Bonnard taking this picture

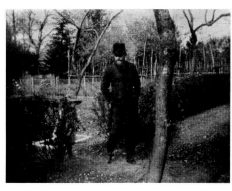

104 - Ker-Xavier Roussel followed by Renée
Original negative
Plate 39

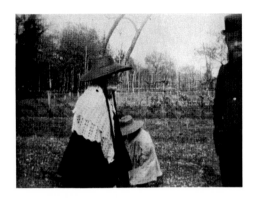

105 - Madame Mertzdorff, Renée, and, at the far right, Ker-Xavier Roussel
Original negative
Original print, printed on the same sheet as cat. no. 100, 3.8 × 5.1 cm ($1\frac{1}{2}$ × 2 in.)

106 - Madame Mertzdorff and a nursemaid holding Vivette
Original negative

107 - An unknown woman, Renée Terrasse, a little girl with flowers, and, to the right, Andrée Terrasse holding Vivette
Original print, 5.7 × 8.3 cm ($2\frac{1}{4}$ × $3\frac{1}{4}$ in.)

Chapter 11: Nudes of Marthe in Bonnard's Parisian apartment – 1899-1900

This chapter contains the first series of photographic nudes that Bonnard took of Marthe, approximately six or seven years after they first met. A relatively large number of prints from this series were printed by the artist (or he had them printed), but the majority of the negatives have disappeared.

The setting of the photographs is a corner of Bonnard's apartment, located next door to his studio at 65, rue Douai. Marthe is posed on a bed in front of a fireplace that is found in *Intérior* or *Salle à manger*, c. 1899 (D.215); on the wall to the left of the fireplace is an Indian fabric that is present in several canvases, in particular *La Sieste*, 1900 (D.227). A few paintings of this period depict Marthe lying on a bed, for example, *Nu couché, bras levé*, 1898 (D.183), shows a direct relation between the pose and the photograph, while *L'Indolente*, 1899 (D.219; plate X) and *La Sieste*, 1900 (D.227) plate IX) are much more elaborate in their layout.

However, it is above all in the many illustrations for Verlaine's *Parallèlement*, published by Vollard in September 1900, that the connections between photography and graphic work can be made. Marthe can be recognized in several of the lithographs, in similar poses to those in this series. Although the transition from photograph to lithograph is less literal than in the later series of illustrations for *Daphnis et Chloé* (see chap. 12), there is no doubt that Bonnard referred to these photographs for the Verlaine prints. The comparisons that are made in detail in the catalogue entries allow these photographs to be dated in 1899 or early 1900.

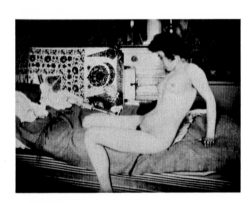

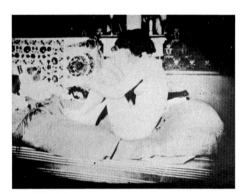

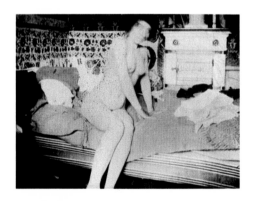

108 - Marthe seated in profile
Original negative
Two original prints, one printed on the same sheet as cat. no. 112, 4.0 × 5.1 cm ($1\frac{5}{8}$ × 2 in.) and 3.8 × 5.1 cm ($1\frac{1}{2}$ × 2 in.)
Directly related to the illustration for the last stanza of "Limbes" (p. 77) of Verlaine's *Parallèlement* (Bouvet 73, p. 122; plate II).
Plate 17
Plate I

109 - Marthe seated with her arms around her bent knees
Two original prints, one printed on the same sheet as cat. no. 113, 3.8 × 5.1 cm ($1\frac{1}{2}$ × 2 in.)

110 - Marthe leaning forward
Original negative
Original print, 3.8 × 5.1 cm ($1\frac{1}{2}$ × 2 in.)

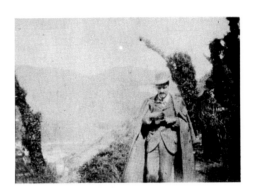

140 - Vuillard seated in a room at the Grand Hôtel Inglès in Madrid
Two original prints, one printed on the same sheet as cat. nos. 141, 142, and 143, 3.6 × 5.1 cm (1⅜ × 2 in.)
Inscription by Bonnard on the verso of the photograph: *La fumeur d'opium* (The opium smoker).

141 - Vuillard in the room at the Gran Hôtel Inglès in Madrid
Original print, printed on the same sheet as cat. nos. 140, 142, and 143, 3.8 × 5.3 cm (1½ × 2 1/16 in.)

142 - Emmanuel Bibesco (about to take Bonnard's photograph?)
Original print, printed on the same sheet as cat. nos. 143, 140, and 141, 3.8 × 5.1 cm (1½ × 2 in.)

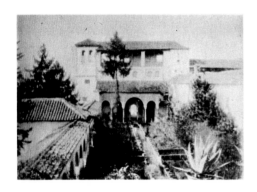

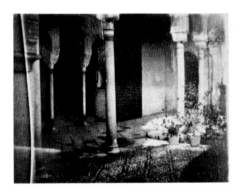

143 - Hacienda seen from a garden, in Andalusia
Original print printed on the same sheet as cat. nos. 142, 140, and 141, 3.8 × 5.1 cm (1½ × 2 in.)

144 - View of a village taken from a terrace
Original print, printed on the same sheet as cat. nos. 145, 146 and 147, 3.8 × 5.1 cm (1½ × 2 in.)

145 - Columns of a portico
Original print, printed on the same sheet as cat. nos. 144, 146, and 147, 3.8 × 4.7 cm (1½ × 1⅞ in.)

146 - Village square viewed from above (Basque country?)
Original print, printed on the same sheet as cat. nos. 147, 144, and 145, 3.8 × 5.1 cm (1½ × 2 in.)

147 - Spanish landscape with some houses and a church in the distance
Original print, printed on the same sheet as cat. nos. 146, 144, and 145, 3.8 × 5.1 cm (1½ × 2 in.)

Using one of his favorite manners of posing groups, Bonnard has photographed Thadée Natanson, his wife Misia, and her sister-in-law Ida Godebska. This photograph was taken during a visit to Grand-Lemps in 1902.

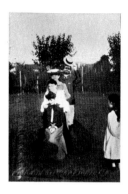

148 - From front to back: Andrée Terrasse, Ida Godebska, Misia Godebska, and Thadée Natanson (?); at right is Renée
Original print, 11.0 × 8.0 cm
(4 3/8 × 3 1/8 in.)

Chapter 15: Montval, Family scenes – circa 1902

This chapter comprises a series of photographs taken at Montval, near Paris, during visits by various persons, including Charles Bonnard and his family. It is possible that these images (or certain of them) were taken the year that Bonnard photographed Marthe in the garden (see chap. 12). The age of the persons photographed, however, suggests that they may have been taken later. Charles Bonnard was married in 1900 and this is the first time that his wife appears in these photographs. A nude of Marthe (cat. no. 123) was printed together with a scene from this series (cat. no. 151), but the negatives are separated on the sheet and certainly did not follow on a single roll of film.
Among the persons photographed here is the lithographer Clot (cat. no. 158), Vollard's printer, who was also photographed by Vuillard at Roussel's house in l'Etang-le-Ville in 1902.[13] Clot's presence can be explained by the publication that year of *Daphnis et Chloé* (unless perhaps the visit concerned *Parallèlement* – in which case the photograph would date from 1900).

Many of these photographs help us to form a picture of the layout of the property at Montval, which still exists today, but has undergone some alterations. One enters a courtyard through a gate in a fence which extends the line of the building's lateral facade; entrance to the garden is through a small door visible in several photographs (cat. nos. 162-164). The figures posing in the garden (cat. nos. 151, 153-155) are all located in front of that same doorway on the garden side. The main facade of the house has three arched windows originally decorated with geometric designs (cat. nos. 156-159). Several scenes (cat. nos. 149 and 150), take place in the garden near where Bonnard photographed Marthe in the series of nudes.

13. Jacques Saloman "Vuillard et son Kodak,"
L'Oeil (Paris), no. 100, (April 1963): 17

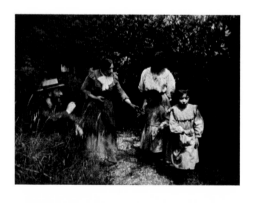

149 - Charles and Eugénie Bonnard, Marthe, and two little girls
Original negative
Plate 47

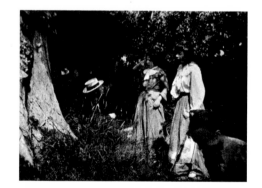

150 - Charles and Eugénie Bonnard, Marthe and a little girl
Original negative
Plate 46

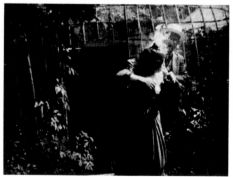

151 - Charles and Eugénie Bonnard
Original print (image reversed), printed on the same sheet as cat. no. 123 (separate negative), 3.6 × 5.6 cm (1 7/16 × 2 3/16 in.)

152 - Charles and Eugénie Bonnard
Original negative
Plate 48

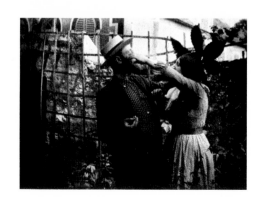

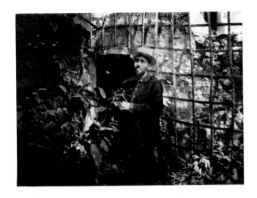

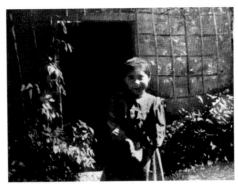

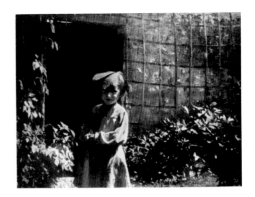

153 - Charles Bonnard
Original negative

154 - A little girl
Original negative
Plate 50

155 - A little girl wearing a crown of leaves
Original negative
Plate 51

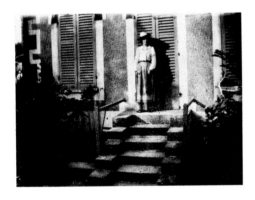

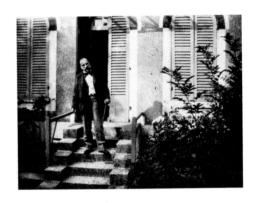

156 - Marthe in front of the main facade
Original negative

157 - Marthe descending the staircase
Original negative

158 - The lithographer Clot, Vollard's printer
Original negative
Original print, printed on the same sheet as cat. no. 159,
4.0 × 5.5 cm ($1\frac{9}{16}$ × $2\frac{3}{16}$ in.)

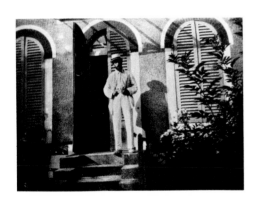

159 - Pierre Bonnard in front of the main facade
Original negative
Original print, printed on the same sheet as cat. no. 158, 3.1 × 5.2 cm
($1\frac{1}{2}$ × 2 in.)

160 - A horse in the first yard at Montval
Original negative

161 - A horse grazing in the first yard at Montval
Original negative

 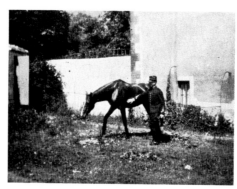 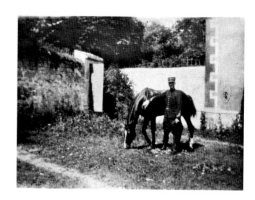

162 - A horse in motion
Original negative

163 - A soldier stroking a horse
Original negative

164 - A soldier stroking a horse
Original negative

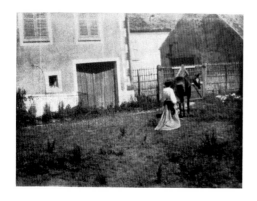 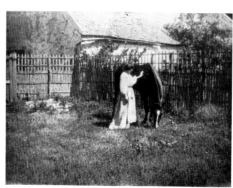 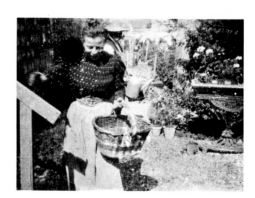

165 - Marthe and a horse
Original negative
Plate 44

166 - Marthe stroking a horse
Original negative
Plate 45

167 - A housekeeper
Original negative

168 - A couple of domestics
Original negative

Chapter 16: Paris, Family scenes in Bonnard's studio, rue de Douai — circa 1902-03

 In 1899, Bonnard left his studio in Batignolles and moved to 65, rue de Douai, near Pigalle. "The other day, I was walking along the Rue de Douai and I saw: 'studio with apartment to let'. I had a look at it: A wonderful view from the studio over the convent garden toward Montmartre. Well, I mortgaged the future a little and went wild and rented it." [14]

 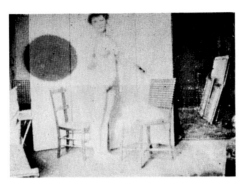 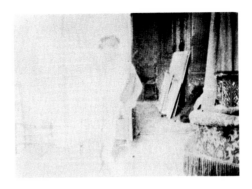

197 - Model standing with her arms crossed behind her back
Original print, printed on the same sheet (separate negatives) as cat. nos. 203, 202, and 204, 3.8 × 5.0 cm. (1½ × 2 in.)

198 - Model standing with her left hand behind her
Original print, printed on the same sheet as cat. nos. 199, 200, and 201, 3.8 × 5.1 cm (1½ × 2 in.)
Inscription on the verso of the page in pencil in Bonnard's handwriting: *Modèles dans l'atelier*

199 - Model seated facing the camera
Original print, printed on the same sheet as cat. nos. 198, 200, and 201, 3.8 × 5.1 cm (1½ × 2 in.)

200 - Model leaning forward on her left leg
Original print, printed on the same sheet as cat. nos. 201, 198, and 199, 3.7 × 5.1 cm (1½ × 2 in.)

201 - Model standing with her back to the camera
Original print, printed on the same sheet as cat. nos. 200, 198, and 199, 3.7 × 5.1 cm (1½ × 2 in.)

Chapter 22: Visit to the seaside – July 1904 or August 1906 (?)

These two photographs seem to have been taken on a beach on the Channel coast of France, but it is difficult to be certain of the location or the date. It is known that Bonnard visited Varengeville, near Dieppe, in July 1904, and Wimereux, near Boulogne-sur-Mer, in August 1906. Since one of the photographs from the previous series, (cat. no. 197) dated 1905, has been printed with these images, these two groups date from the same period. The setting could also be a beach in Holland or Belgium, if the photographs were taken during Bonnard's trip on the Albert Edwards' yacht (see chap. 23). Although the house with the wooden balcony (cat. no. 204) bears some resemblance to Roussel's mother's house in L'Etang-la-Ville, visited by Bonnard in 1904 and 1906, this cannot be claimed with any certainty.

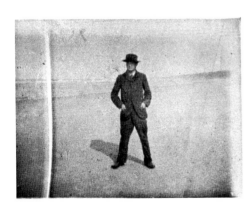 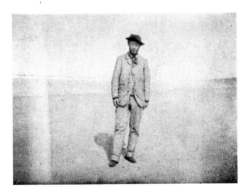

202 - Man on a beach
Original print, printed on the same sheet as cat. nos. 204, 203, and 197, 3.7 × 4.8 cm (1½ × 1⅞ in.)

203 - Pierre Bonnard on a beach
Original print, printed on the same sheet (separate negatives) as cat. nos. 197, 202, and 204, 3.8 × 5.0 cm (1½ × 2 in.)

204 - House with a wooden balcony and stairway
Original print, printed on the same sheet as cat. nos. 202, 203, and 197, 2.8 × 5.0 cm (1⅛ × 2 in.)

Pierre Bonnard took at least two cruises on Misia and Albert Edward's yacht, *Aimée* (a pun involving the phonetic union of the initials "E" for Edwards and "M" for Misia).[15] Maurice Ravel later worked on the score for *Daphnis et Chloé* on this yacht.

The first voyage, in July 1905, was to Amsterdam via the Meuse. Bonnard brought back a sketchbook of drawings (private collection). Another series of photographs date from July and August 1906, during Bonnard's second voyage. In addition to Bonnard, the other passengers on this trip were Marthe and her dog Black, the Edwards, and Misia's half-brother, Cipa Godebski. The yacht's itinerary is known from post cards sent by Bonnard to his mother and to Vuillard. After some time on the yacht, Bonnard returned to Paris for the Fourteenth of July and then rejoined the *Aimée* later in Ostend. After a second visit to Belgium and Holland, the boat finally moored at Valvins in late August and early September.[16]

About this time, Bonnard finished his painting representing Misia, Albert, and Cipa seated on the boat deck, *Sur le yacht d'Edwards*, 1906 (D.417; pl. XIV). Bonnard's sketchbook contains a drawing of Albert and Misia Edwards in which they are wearing the same clothes as in the photograph (cat. no. 207).[17]

15. Antoine Terrasse, *Bonnard en Hollande*, catalogue of the exhibition "Salon de Fontainebleau", Fontainebleau, 1987, n.p.

16. Letter to his mother. (Private collection)

17. Reproduced in Antoine Terrasse, *Bonnard en Hollande*. n.p.

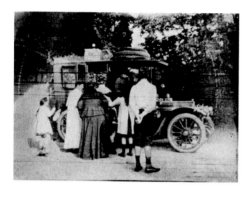

205 - The Edward's departure from Grand-Lemps
Original print, 4.1 × 5.6 cm
(1⅝ × 2¼ in.)

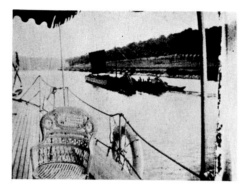

206 - The deck of the yacht *Aimée*
Original print, 3.6 × 5.3 cm
(1⅜ × 2 in.)

207 - Misia and Albert Edwards on the deck
Original print, 3.7 × 4.5 cm
(1 1/16 × 1¾ in.)

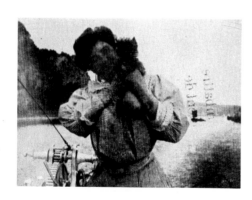

208 - Misia holding her griffon terrier
Two original prints, 3.7 × 5.1 cm
(1 1/16 × 2 in.)

209 - Cipa Godebski on the yacht *Aimée*
Original print, 3.8 × 5.2 cm
(1½ × 2 in.)
Plate 79

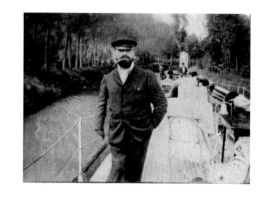

210 - Cipa Godebski and, in the background, Marthe and her dog Black
Original print, 3.7 × 5.2 cm
(1 1/16 × 2 in.)

211 - Black sleeping on the yacht *Aimée*
Three original prints, 3.7 × 5.2 cm
(1 1/16 × 2 in.)
Plate 80

The first three photographs of this chapter were taken during a stay at a cottage near Paris, most likely one of the two that the artist rented at Vernouillet in 1907. The date 1907 can be ascertained because the painting *La Toilette* (D. 486), dating from this year, shows the same interior as the photograph of Marthe in a tub (cat. no. 214).

Although previously attributed to an anonymous photographer,[18] the photographs of Bonnard and a woman (cat. nos. 212 and 213) undoubtedly come from Bonnard's negatives and are in the same spirit as his more monumental images of the 1910s. The blur in the foreground of some photographs (cat. nos. 214 and 216) is caused by the corner of a table.

In the self-portrait of Bonnard (cat. no. 213), the dressing table with skirt visible through the doorway is the same one that appears behind Marthe as she washes in a tub (cat. no. 214). This photograph constitutes a point of departure for Bonnard's extensive series of bathing scenes in which the nude is represented from the front, including a series of drawings (the sketchbook from 1912 in a private collection); a poster for the Salon d'Automne, 1912 (Bouvet 79); and seven canvases carried out between 1913 and 1924 (D.773, 1913; D.886, 1916; D.896, c. 1917; D.933, 1918; D.02105, c. 1916; D.02130 and D.02131, c. 1917 and D.1280, 1924). Many of these compositions accentuate different motifs from the photographs, such as the doorway, the skirted dressing table, or the tiled floor. Marthe's pose (cat. no. 214) is very close to that of several of the paintings (especially D.886 and D.02131). This theme eventually was abandoned in favor of nudes in bathtubs.

The dressing table and mirror (a favorite device of Bonnard's) appear in a painting dating as early as 1907, *La Toilette* (D.486), in *La Glace du cabinet de toilette* , 1907 or 1908 (D.488), and again in *La Toilette au bouquet rouge et jaune*, before 1913 (D.772). In *Nu à contre-jour*, 1908 (D.481), Bonnard has changed the decor of the room and in order to create the effect of light, placed a window next to the dressing table.

We know that Bonnard often worked from memory and that, moreover, the dates of his works may reflect only the completion of a canvas begun several years earlier. In addition, certain themes were examined over extended periods throughout the artist's work. In this case, the photographs seem to have preceded the painted and graphic versions. These images were constantly being rethought, though each appears to be a perfectly elaborated composition.

18. Jean-Francoise Chevrier, "Bonnard and photography," In *Bonnard: The Late Paintings*, p. 84

212 - Woman seated at a table
Original negative, 8.0 × 5.5. cm
(3⅛ × 2⅛ in.)

213 - Pierre Bonnard
Original negative, 8.0 × 5.5. cm
(3⅛ × 2⅛ in.)

214 - Marthe bathing
Original negative, 7.8 × 5.5 cm
(3 × 2⅛ in.)
Plate 59

Chapter 25: Sojourn at Veronnet – circa 1910-15

Bonnard visited Veronnet, near Vernon, in the Eure department, for the first time in 1910. He rented a property called "Ma Roulotte" (My Caravan), that he eventually bought in 1912. Bonnard and Marthe often visited Veronnet, even after they bought the villa "Le Bosquet" (The Grove), at Cannet in 1925. The house at Veronnet was sold in 1937.

Bonnard painted many canvases at Veronnet, in particular the painting set on the terrace of "Ma Roulotte" (as in cat. nos. 215 and 216), overlooking the Seine, *La Terrasse de Vernon*, c. 1928 (D.1389).

While at Veronnet, Bonnard paid frequent visits to his neighbor, Claude Monet, who he photographed at least once in the park at Giverny in 1912. The Bonnard archives also contain a negative of the same size, showing Monet visiting Bonnard and Marthe in Paris, but the photograph was taken by someone else, probably at Bonnard's request, and is not included in this catalogue.

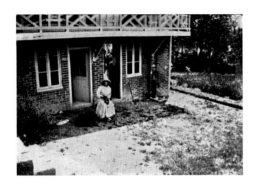

215 - Marthe seated in front of "Ma Roulotte" accompanied by Black
Original print, 5.8 × 8.3 cm
(2 1/4 × 3 1/4 in.)

216 - Marthe seated on the terrace of "Ma Roulotte"
Original negative, 8.0 × 5.5 cm
(3 1/8 × 2 1/8 in.)
Plate 60

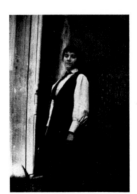

217 - Marthe and the Godebskis in a rowboat: Marthe and Ida Godebska facing front, Cipa (in close-up) rowing
Original negative, 8.0 × 5.5 cm
(3 1/8 × 2 1/8 in.)
Two original prints, 13.0 × 18.0 cm
(5 1/8 × 7 1/4 in.)
Plate 56

218 - Claude Monet (and an unidentified person) walking, Giverny
Original negative, 8.0 × 5.5 cm
(3 1/8 × 2 1/8 in.)

Chapter 26: A model in the artist's studio – circa 1916

This model can be recognized in several of Bonnard's canvases from around 1916, such as *Buste de femme couchée* (D.02106; fig. 12), *Jeune femme en chemise, allongée* (D.02107), and *Jeune femme à la gorge découverte* (D.02108). She also appears in several paintings from the same year in bust-length or half-length portraits.

In several photographs (cat. nos. 214-221), Bonnard created remarkable portraits and gave his sitter a monumental aspect. The photograph of the model undressing (cat. no. 222), shows a corner of Bonnard's studio at 22, rue de Tourlague; he retained this studio from 1911 until his death in 1947. As in many of his paintings, in this photograph Bonnard makes use of the mirror: reflected in it is the bust of Antinous that also appears in the photograph of the artist's family at his studio at Rue de Douai (cat. no. 169) and in a rare canvas depicting a part of his studio, *Nature morte au buste d'Antinous*, c. 1925. D.1306).

Three prints from this series (cat. nos. 219, 220, and 222), given to the model by Bonnard, were acquired by the Musée d'Orsay on the Paris market in 1985.

219 - Model wearing a hat standing in front of the studio door
Original negative, 8.0 × 5.5 cm (3 1/8 × 2 1/8 in.)
Original print, 8.8 × 5.9 cm (3 1/2 × 2 5/16 in.)
Contemporary enlargement on silver paper, 13.0 × 18.0 cm (5 1/8 × 7 1/4 in.)

221 - Model with a cat
Original negative, 8.0 × 5.5 cm (3 1/8 × 2 1/8 in.)
Contemporary enlargement on silver paper, 13.0 × 18.0 cm (5 1/8 × 7 1/4 in.)
Plate 57

220 - Model standing in front of the studio door
Original negative, 8.0 × 5.5 cm (3 1/8 × 2 1/8 in.)
Original print, 8.8 × 5.9 cm (3 1/2 × 2 5/16 in.)
Contemporary enlargement on silver paper, 13.0 × 18.0 cm (5 1/8 × 7 1/4 in.)

222 - Model removing her blouse in the artist's studio
Original negative, 8.0 × 5.5 cm (3 1/8 × 2 1/8 in.)
Original print, 8.8 × 5.9 cm (3 1/2 × 2 5/16 in.)
Contemporary enlargement on silver paper, 13.0 × 18.0 cm (5 1/8 × 7 1/4 in.)
Plate 58

Bonnard professed a great admiration for Auguste Renoir, the only artist whose portrait he carried out in an engraving. These two photographs might have resulted from a meeting between the two artists sometime in 1916. Although the photographs seem to have aided Bonnard in his etching, it is not certain that he took them. In fact, these prints (from Bonnard's archives) are different from those by the artist and do not contain the usual technical faults that one finds in his negatives of this period. The negative of the portrait of Renoir (cat. no. 223) was found in the archives of Claude Monet, but contrary to what has been suggested, it was not taken by Monet. Still, as we have been unable to compare this negative with Bonnard's, the issue of its attribution remains open.

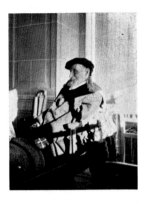

223 - Auguste Renoir
Original print, 10 × 7.6 cm
(4 × 3 in.)
Inscription on verso in Bonnard's
handwriting: *Renoir*
See the etching by Bonnard, *Portrait
of Renoir*, c. 1916 (Bouvet 84)
fig. 13

224 - Auguste and Jean Renoir
Original print, 10.2 × 7.6 cm
(4 × 3 in.)
Inscription on verso in Bonnard's
handwriting: *Renoir*

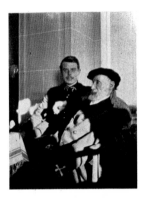

Appendix: Photographs by Edouard Vuillard taken at Grand-Lemps — Spring 1900

This appendix draws together a series of seven photographs by Vuillard (4 negatives and 3 prints from lost negatives) that were taken at Grand-Lemps in 1900. During this vacation, Vuillard, Bonnard, and Roussel were guests of Bonnard's mother, Madame Eugène Bonnard. These images (pl. 81-84 and pl. XVI, top and bottom) were given to Bonnard by Vuillard. During this visit Bonnard also took photographs (cat. nos. 100-107). Vuillard's photograph (App. A) shows Bonnard at work: he is taking a photograph of Renée as she turns toward Vuillard (cf., pl. 41 and pl. 81).

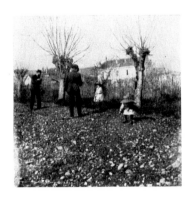

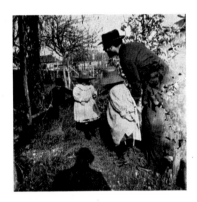

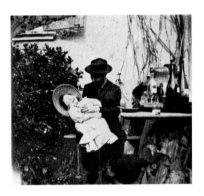

A - Bonnard photographing Renée; Roussel
and an unidentified child
Original negative
Plate 81 and plate 82 (detail)
Cf. plate 41

B - Bonnard, Roussel (seated on the
ground), Renée, and a little girl
Original negative
Plate 85

C - Bonnard tickling Renée
Original print, 8.3 × 8.8 cm
(3¼ × 3½ in.)
Plate XVI (top)

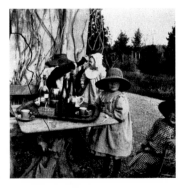

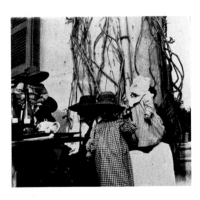

E - Around the table: Bonnard (?) holding
Renée, Madame Mertzdorff, a little girl,
and a servant holding Vivette
Original print, 8.2 × 8.6 cm
(3¼ × 3⅜ in.)
Plate XVI (bottom)

D - Feeding Vivette: Madame Mertzdorff,
Vivette, Renée, and an unidentified
child
Original negative
Plate 84

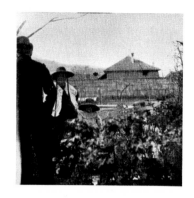

F - Roussel, Madame Mertzdorff, and Renée
Original negative
Plate 83

G - Madame Eugène Bonnard, Misia, and Ida Godebksa
Original print, 8.0 × 8.9 cm
($3\frac{1}{8}$ × $3\frac{1}{2}$ in.)

COLOR PLATES

Plate I
1. Marthe (nos. 112 and 108)
1899-1900
2. Marthe (nos. 116 and 114)
1899-1900
3. Marthe (nos. 131 and 129)
1900-1901

Plate II
Limbes, illustration accompanying the last stanza of the poem of the same name, page 77 of Verlaine's *Parallèlement,* published by Vollard in 1900.
Lithograph in pink sanquine
30.5 × 25 cm, 2.2 × 10 in. (the page)
Private collection

Plate III
Eté, illustration accompanying the last two stanzas of the poem of the same name, page 18 of Verlaine's *Parallèlement,* published by Vollard in 1900.
Lithograph
30.5 × 25 cm, 2.2 × 10 in. (the page)
Unlettered proof in pink sanquine
Private collection

Plate IV
Daphnis et Chloé
Illustration for Longus's pastoral, published by Vollard in 1902
Plate 69
Lithograph
30.5 × 25 cm, 12.2 × 10 in. (the page)
Unlettered proof in blue ink.
Private collection

Plate V
Daphnis et Chloé
Illustration for Longus's pastoral, published by Vollard in 1902
Plate 185
Lithograph 30.5 × 25 cm, 12.2 × 10 in.
Unlettered proof in blue ink
Private collection

Plate VI
La leçon d'amour dans un parc (Lessons of love in a park)
Cover illustration for Rene Boylesve's novel.
Published by "Revue Blanche", 1902
Private collection

Plate VII
La Grand-mère (Grandmother; Portrait of Mrs Mertzdorff)
Oil on cardboard, signed and dated in upper left: *Bonnard 94*
36 × 19 cm, 14.4 × 7.6 in.
Dauberville 68
Musée départemental du Prieuré, Saint-Germain-en-Laye

Plate VIII
La Partie de croquet (The Game of Croquet)
Oil on canvas
1892
130 × 160 cm, 2 × 64 in.
Dauberville 38
Musée d'Orsay, Paris

Plate IX
La Sieste
Oil on canvas, signed in the lower right: *Bonnard*
1900
109 × 132 cm, 43.6 × 52.8 in.
Dauberville 227
National Gallery of Victoria, Melbourne

Plate X
L'Indolente (Indolence)
Oil on canvas, signed and dated in lower left: *99 Bonnard*
96 × 105 cm, 38.4 × 42 in.
Dauberville 219
Musée d'Orsay, Paris

Plate XI
L'Homme et la Femme (A Man and a Woman)
Oil on canvas, signed and dated in lower left: *Bonnard 1900*
115 × 72 cm, 46 × 28.8 in.
Dauberville 224
Musée d'Orsay, Paris

Plate XII
L'Après-midi bourgeoise ou la famille Terrasse
Oil on canvas, signed and dated in the lower left: *Bonnard 1900*
139 × 212 cm, 55.6 × 84,8 in.
Dauberville 234 or 272
Bernheim-Jeune collection

Plate XIII
Portrait of Claude Terrasse
Oil on canvas
Circa 1902-1903
95 × 77 cm, 38 × 30.8 in.
Dauberville 275
Musée d'Orsay, Paris
(Gift of Mr Charles Terrasse)

Plate XIV
Sur le yacht d'Edwards (On the Edwards' yacht)
Oil on wood, signed in lower right: *Bonnard*
Circa 1906
37.4 × 45.9 cm, 14.9 × 18.3 in.
Dauberville 417
Musée de la ville de Poitiers

Plate XV
Nu au tub (Nude in a tub)
Oil on canvas, bearing the studio stamp in the upper left
Circa 1916
140 × 102 cm, 56 × 40.8 in.
Dauberville 2105
Private collection

Plate XVI
1. Edouard Vuillard : *Family scene at Grand-Lemps* (see Appendix Vuillard E)
2. Edouard Vuillard : *Bonnard tickling Renée* (see Appendix Vuillard C)

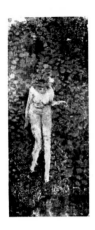

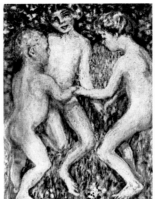

Figure 1 *Nude against a background of foliage*
Oil on canvas
1894
140 × 60 cm, 56 × 16 in.
Dauberville 73
Private collection

Figure 2 *Facade of the Château Sarazin at Grand-Lemps*
Pencil drawing
Sheet 34 (verso), of a sketchbook dating
1894-1895
Private collection

Figure 3 *Three nude children*
Oil on canvas, signed in the upper left
According to Charles Terrasse, painted in summer
1899
67 × 52 cm, 26.8 × 20.8 in.
Dauberville 194
Private collection

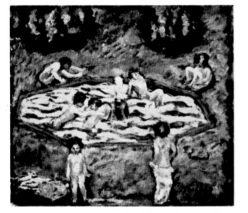

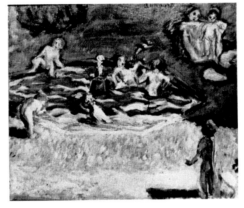

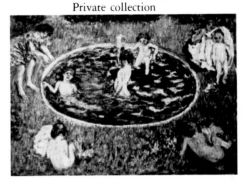

Figure 4 *Bathing at Grand-Lemps*
Oil on canvas, signed in lower left
1899
35.2 × 41 cm, 14 × 16.4 in.
Dauberville 191
Private collection

Figure 5 *Bathing at Grand-Lemps*
Oil on canvas, signed in upper right
1899
36 × 43 cm, 14.4 × 17.2 in.
Dauberville 192
Private collection

Figure 6 *Children in a Pool*
Oil on wood signed and dated in lower left: 99 *Bonnard*
50 × 71.5 cm, 20 × 28.6 in.
Dauberville 1797
Private collection

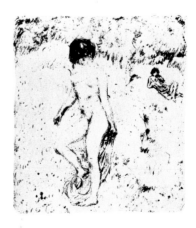

Figure 7 *The Terrasse children in the garden at Grand-Lemps* (La verdure au basset)
Oil on canvas signed in lower right
Circa 1901
48 × 62 cm, 19.2 × 24.8 in.
Dauberville 256
Private collection

Figure 8 *Charles Terrasse*
Oil on cardboard
1903
47 × 34 cm, 18.8 × 13.6 in.
Dauberville 1848
Private collection

Figure 9 Plate from *Daphnis et Chloé*
Bouvet 75
1902
Private collection

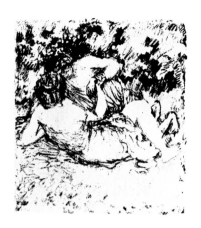

Figure 10 Plate from *Daphnis et Chloé*
Bouvet 75
1902
Private collection

Figure 11 Plate from *Daphnis et Chloé*
Bouvet 75
1902
Private collection

Figure 12 *Bust of Woman Lying on her Side*
Oil on canvas signed in lower right
Circa 1916
Dauberville 2106
Private collection

Figure 13 *Portrait of Renoir*
Etching
Circa 1916
27 × 20 cm, 10.8 × 8 in.
Bouvet 84
Private collection

Figure 14 Edouard Vuillard : *Pierre Bonnard holding his camera*
Detail of the cat. no. H.C. 3

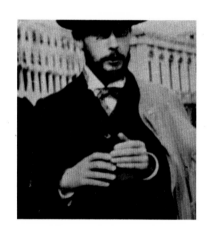

Photographic credits

Bernheim-Jeune : figures 1, 3, 4, 5, 6, 7, 8, 12
Musée des Beaux-Arts, Poitiers : plate XIV
Musée départemental du Prieuré, Saint-Germain-en-Laye : plate VII
Musée national d'Art moderne, Paris : plates IX, XII, XV
Réunion des Musées nationaux (photos J.J. Sauciat and P. Schmidt) :
plates I, II, III, IV, V, VIII, X, XI, XIII ; figures 2, 9, 10, 11, 13
Laurent Sully-Jeaulmes : plate VI

Photographs by Bonnard previously published (the numbers refer to this book and are presented in the order of their prior publication):

Erika Billeter, 1979 : nos 112, 100, 108, 224, 218, 6, 80, 34
Jean-François Chevrier, 1984 : nos 212, 213, 6, 13, 108, 111, 1, 8, 7, 221, 216, 130, 135, 137, 214, 110, 36, 23, 188, 81
Sylviane de Decker-Heftler, 1984, nos 133, 137, 130
Françoise Heilbrun et Philippe Néagu, 1984 : nos 18, 80, 23, 4, 134, 214.

Bibliography

Bareau, Juliet Wilson. "Edouard Vuillard et les princes Bibesco," *Revue de l'Art* (Paris), no 74 (1986) : 37-46.

Bonnard, Pierre. *Correspondances*, Edited by Tériade. Paris : Éditions de la Revue Verve, 1944.

Bordeaux. Galerie des Beaux-Arts. *Hommage à Bonnard*, May 10-August 25, 1986. Texts by Claire Frèches-Thory and Philippe Le Leysour.

Bouvet, François. *Bonnard: The Complete Graphic Work*. Translated from the French by Jane Brenton. New York: Rizzoli, 1981; Paris: Flammarion, 1981.

Bouvier, Marguette. "Pierre Bonnard revient à la litho..." *Comoedia* (Paris), no 82 (January 23, 1943).

Chevrier, Jean-François. "Bonnard and photography." In *Bonnard: The Late Paintings*. Edited by Sasha M. Newman. Paris : Musée National d'Art Moderne ; Washington, D.C.: The Phillips Collection; Dallas, Dallas Museum of Art, 1984.

Clair, Jean. "The adventures of the optic nerve." In *Bonnard: The Late Paintings*. Edited by Sasha M. Newman. Paris : Musée National d'Art Moderne ; Washington, D.C.: The Phillips Collection; Dallas, Dallas Museum of Art, 1984.

Dauberville, Jean and Henry. *Bonnard : Catalogue raisonné de l'œuvre peint*. 4 vols. Paris : Editions J. et H. Bernheim-Jeune, 1965-74.

de Decker-Heftler, Sylviane. "Le Nu photographie." *Photographies* (Paris), n° 6 (1984): 74

Fermigier, André. *Pierre Bonnard*. New York: Harry B. Abrams, 1969; Paris : Editions Cercle d'Art, 1969.

Frèches-Thory, Claire. "Pierre Bonnard : tableaux récemment acquis par le musée d'Orsay." *La Revue du Louvre* (Paris), 36 ann., n° 6 (1984) : 417-431.

—. "Bonnard nabi." In *Hommage à Bonnard*. Bordeaux : Galerie des Beaux-Arts, 1986 : 15-25.

Fontainebleau. "Salon de Fontainebleau." *Bonnard en Hollande*, Text by Antoine Terrasse.

Heilbrun, Françoise, and Philippe Néagu. "Bonnard intime." *Beaux-Arts* (Paris), no 11 (1984) : 68-71.

Josipovici, Gabriel. *Contre-jour : A Triptych After Pierre Bonnard*. Manchester: Carcanet Press, 1986.

Le Leysour, Philippe. "Sur Bonnard : Propos et critiques, 1943-1985." In *Hommage à Bonnard*. Bordeaux : Galerie des Beaux-Arts, 1986 : 27-36.

Leymarie, Jean. *Bonnard dans sa lumière*. Saint-Paul-de-Vence : Fondation Maeght, 1975 ; Paris : Maeght Editeurs, 1978.

London. National Portrait Gallery. *Staging the Self: Self-Portrait photography. 1840s-1980s*. October 3, 1986-January 11, 1987, plus travel. Texts by James Lingwood, Jean-François Chevrier, Susan Butler, David Mellor.

Natanson, Thadée. *Peint à leur tour*. Paris: Editions Albin Michel, 1948.

—. *Le Bonnard que je propose*. Geneva : Pierre Cailler, 1951.

Paris. Galerie Claude Bernard. *Pierre Bonnard : dessins et acquarelles*, September-October 1977. Text by Antoine Terrasse.

Paris. L'Oeil, galerie d'art. *Vuillard et son kodak*, April 25-May 26, 1963; traveled to London, Lefevre Gallery, March 3-26, 1964 (diff. cat.). Texts by Jacques Salomon and Annette Vaillant (trans. in London cat.).

Paris. Musée National d'Art Moderne, Centre Georges Pompidou. *Bonnard: The Late Paintings*, February 23-May 21, 1984; traveled to The Phillips Collection, Washington, D.C., June 9-August 25, 1984; Dallas Museum of Art, Dallas, September 13-November 11, 1984. Texts by Jean Clair, Jean-François Chevrier, Margret Hahnloser-Ingold, Steven A. Nash, Sasha M. Newman, and John Russell. Edited by Sasha M. Newman.

Paris. Orangerie des Tuileries. *Edouard Vuillard. K.-X. Roussel*. May 28-Sept. 16, 1968; also shown at Haus der Kunst, Munich, March 16-May 12, 1968. Texts by Jacques-Salomon and Claude Roger-Marx.

Salomon, Jacques. *Vuillard*. Paris: Gallimard, 1968.

—. "Propos sur l'amitié de K.-X. Roussel et Edouard Vuillard." In *Edouard Vuillard, K.-X. Roussel* (Paris : Orangerie des Tuileries, 1968), pp. 13-21.

Salomon, Jacques, and Annette Vaillant. "Vuillard et son Kodak," *L'Oeil* (Paris), no 100 (April 1963): 14-25.

Terrasse, Antoine. *Bonnard*. Translated from the French by Stuart Gilbert. Geneva: Skira, 1964.

—. *Pierre Bonnard*. Paris : Gallimard, 1967.

—. *Degas et la photographie*. Paris : Denoël, 1983.

—. "Bonnard's notes" and "Chronology." In *Bonnard: The Late Paintings*. Edited by Sasha M. Newman. Paris : Musée National d'Art Moderne ; Washington, D.C.: The Phillips Collection; Dallas, Dallas Museum of Art, 1984.

Terrasse, Charles. *Bonnard*. Paris : Henri Floury, 1927.

—. "Maisons de compagne de Bonnard," *Formes et Couleurs* (Paris), 6 ann., no 2 (1944) : 27-38.

Vaillant, Annette. *Bonnard*. Translated from the French by David Britt. New York: New York Graphic Society, 1966; Neuchatel: Ides et Calendes, 1966.

Zurich. Kunsthaus Zurich. *Malerei und Photographie in Dialog, von 1840 bis heute*, Texts by Edited by Erika Billeter.

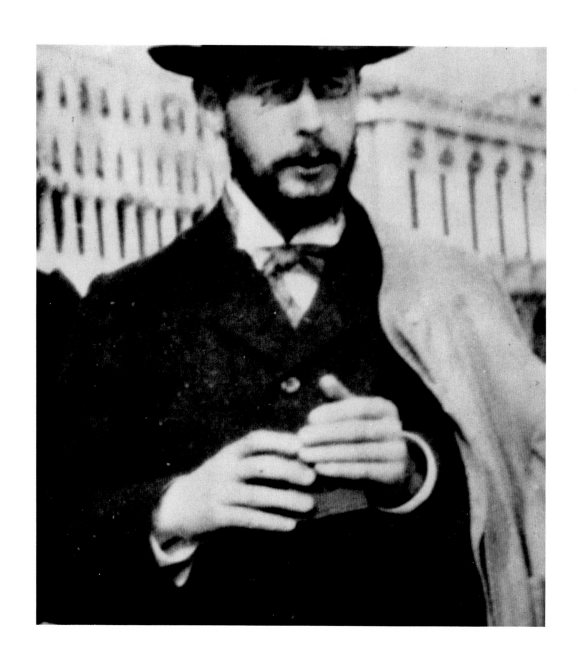